PHOTOGRAPHERS ON PHOTOGRAPHY

LAURENCE KING

Published in 2018
by Laurence King Publishing Ltd
361–373 City Road
London EC1V 1LR
United Kingdom
Tel: +44 20 7841 6900
E-mail: enquiries@laurenceking.com
www.laurenceking.com

Reprinted 2018

This book was produced by
Laurence King Publishing Ltd, London

A catalogue record for this book is available
from the British Library

ISBN: 978-1-78627-318-5

Commissioning Editor: Sophie Drysdale
Senior Editor: Charlotte Selby
Design concept: Atelier Dyakova
Designer: Alexandre Coco
Picture Researcher: Peter Kent

Printed in China

ACKNOWLEDGEMENTS
Thank you to Charlotte Selby, Sophie Drysdale,
Jo Lightfoot, Alex Coco, Peter Kent, Angus Hyland,
Laurence King and everyone else at LKP for their
invaluable thoughts and ideas. I am also very grateful
to the following friends for their generous and
insightful feedback: Marcela Lopez, Selwyn Leamy,
Luke Butterly, Nia Pejsak, Esther Teichmann,
Kim Hungerford, Francesco Solfrini, James Bryant,
Muzi Quawson and Gonzaga Gómez-Cortázar.
And finally, a big thank you to all the photographers
who kindly agreed to be part of this book, and
especially to those who contributed an interview.
This book is dedicated to Marcela.

HENRY CARROLL
Henry Carroll is the author of the internationally
bestselling *Read This If You Want To Take Great
Photographs* series of books and founder and former
director of Frui, one of the UK's leading providers of
photography holidays, courses and events. Originally
from London, Henry graduated from the Royal College
of Art in 2005 with an MA in photography and now
lives in Los Angeles.
henrycarroll.co.uk

PHOTOGRAPHERS ON PHOTOGRAPHY

HOW THE MASTERS SEE, THINK & SHOOT

HENRY CARROLL

LAURENCE KING PUBLISHING

CONTENTS

INTRODUCTION.............6

DOROTHEA LANGE.............8

IRVING PENN.............10

MAN RAY.............12

DAVID HOCKNEY.............14

ANSEL ADAMS.............16

HELLEN VAN MEENE.............18

DAIDŌ MORIYAMA.............20

FAY GODWIN.............22

OLIVIA BEE.............24

AN INTERVIEW WITH OLIVIA BEE.............26

RALPH GIBSON.............30

SAUL LEITER.............32

TODD HIDO.............34

MAISIE COUSINS.............36

RICHARD MISRACH.............38

TACITA DEAN.............40

AMALIA ULMAN.............42

ALISON JACKSON.............44

HARLEY WEIR.............46

ESTHER TEICHMANN.............48

AN INTERVIEW WITH ESTHER TEICHMANN.............50

GARRY WINOGRAND.............54

JASON FULFORD.............56

JAMES WELLING.............58

LISETTE MODEL.............60

PAUL GRAHAM.............62

VIVIANE SASSEN.............64

LAIA ABRIL 66

GILLIAN WEARING 68

ALEC SOTH 70

AN INTERVIEW WITH ALEC SOTH 72

JOHN BALDESSARI 76

LARS TUNBJÖRK 78

RICHARD AVEDON 80

WENDY RED STAR 82

DANA LIXENBERG 84

EDWARD WESTON 86

RONI HORN 88

RON JUDE 90

AN INTERVIEW WITH RON JUDE 92

VIK MUNIZ 96

PENELOPE UMBRICO 98

RYŪJI MIYAMOTO 100

BILL HENSON 102

ALVIN LANGDON COBURN 104

ISHIUCHI MIYAKO 106

LIEKO SHIGA 108

BROOMBERG & CHANARIN 110

AN INTERVIEW WITH BROOMBERG & CHANARIN 112

EDDIE ADAMS 116

JOAN FONTCUBERTA 118

CHARLES SHEELER 120

BRANDON LATTU 122

NOBUYOSHI ARAKI 124

WILLIAM HENRY FOX TALBOT 126

FURTHER READING 128

INTRODUCTION

LET'S CONSIDER THE VISIONARIES,
THE GROUNDBREAKERS, THE ORIGINAL THINKERS –
those influential figures from past and present who pushed
photography forward and continue to do so today. How did they –
how do they – approach their craft and what matters most?

Here we have a selection of quotations, photographs and
interviews that offer telling insights into the minds of masters.
Serving as brief introductions to the big ideas, these collective
viewpoints form a thought-provoking photography primer that
will enrich your understanding of the medium you love.

Aimed at the critically curious, think of this book as an extension to
my *Read This If You Want To Take Great Photographs* series. While
that offers a foundation for the technical aspects of photography,
this offers an introduction to the more philosophical. Expect different
opinions ranging from the personal to the practical, the esoteric to
the enlightening. These varied voices come from all genres and eras
and include reflections on contemporary concerns, as well as some
timeless statements from the old masters.

Absorb, question, agree or disagree with what they have to say
(and what I have to say, for that matter) to piece together your own
distinctive philosophy of photography. So dip in and out when in
need of a creative pick-me-up, or simply turn the page to start on
an ever-deepening journey into the most enigmatic art of them all.

A NOTE ON STRUCTURE
Books on photography tend to be organized by chronology, alphabet,
genre or theme. This book, however, is organized by feeling. From one
photographer to the next you will occasionally spot little connections
and contradictions, but rather than impose a rigid structure, all I've
tried to do is manage the conversation so that each voice can be
heard without it becoming an unruly free-for-all of ideas and opinions.

'For better or for worse, the destiny of the photographer is bound up with destinies of a machine.'

Dorothea Lange

B: 1895 / **N:** American / **G:** Documentary

Taken during the Great Depression, Dorothea Lange's photograph shows us the way west, yet the land of opportunity remains unseen and is clearly still some way ahead. Moreover, one senses that as Lange stood in the middle of this long silver road, she was also reflecting on the future of photography at a time of immense social and technological change.

During her lifetime, Lange saw cameras evolve from something slow and cumbersome into something fast and portable. With that change, Lange experienced first hand how the advances of the 'machine' opened up a new world of creative possibilities for the photographer — something we're experiencing again today with the introduction of digital and camera phones.

This dependence on the camera, however, means that photographers are creatively cursed, because every image they make must be a negotiation between man and machine; the photographer takes charge of seeing, and the camera (for the most part) takes charge of recording. This state of compromise has caused photographers to develop a somewhat prickly relationship with their tool of trade. For better or for worse, it's one of love and hate, of respect and resentment.

The Road West, New Mexico, 1938

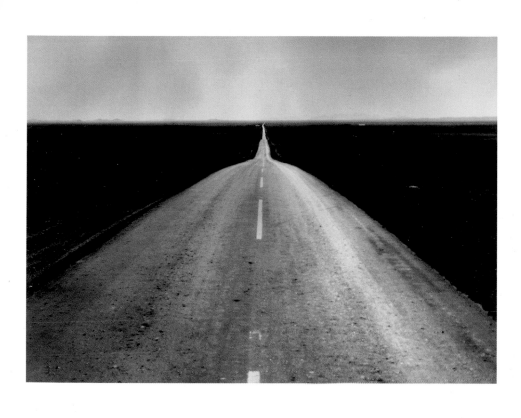

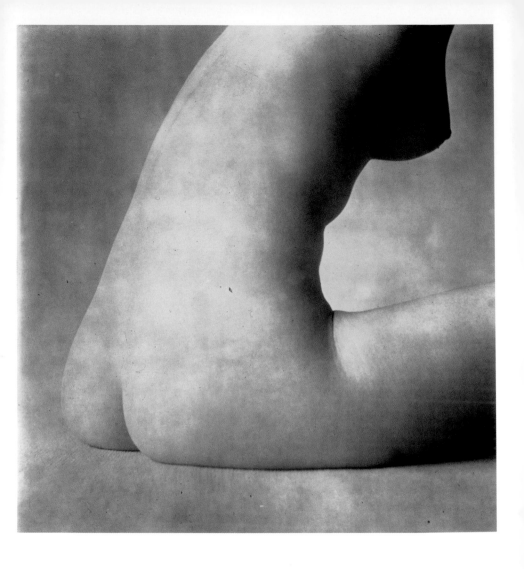

Nude No. 18, New York,
1949–50

'I myself have always stood in awe of the camera. I recognize it for the instrument it is, part Stradivarius, part scalpel.'

Irving Penn

B: 1917 / **N:** American / **G:** Fashion, portraiture, still life

A cut is brutal, even if committed by the blade of a surgeon. So for Irving Penn it seems that the camera is an instrument that creates its art through a form of precise violence – violence because, in order to achieve visual poetry, the photographer must use the camera like a knife, constantly making choices about what to cut from the world and what to keep.

Penn continually drew on this inherent duality within the camera to create lyrical compositions that make us aware of the confines of the frame and the subject's placement within it. As is the case with this nude, we are immediately struck by the severity of the crop, yet by making such a conscious cut, Penn creates an elegant image that edges into abstraction while still celebrating the graceful lines of the female form.

If his camera was a Stradivarius, Penn never misplayed a note. If it was a scalpel, he achieved perfection with every cut.

'People ask, "what camera do you use?" I say, "you don't ask a writer what typewriter he uses.""

Man Ray

B: 1890 / **N:** American / **G:** Fine art

For many fine-art photographers, the question of 'what camera' rings out like a declaration of war. To place emphasis on the camera is to assign value to the work based on how the images were made rather than on their artistry or intended meaning. It suggests that a photographer is a mere technician who has simply learnt how to operate 'a machine'.

As a photographer who constantly experimented with new techniques, Man Ray must have been asked the question more than most. The irony, however, was that some of his most famous images were products of the darkroom rather than the camera. And in the case of his expressively abstract 'Rayographs' (where he placed objects directly onto photosensitive paper to block out the overhead light from the enlarger), Man Ray delighted in removing the camera from the image-making process all together. While this technique is as old as photography itself, his modernist and often indecipherable arrangements remind us that a camera is only one way to make a photograph and that the role of a photographer isn't simply to 'show it how it is'.

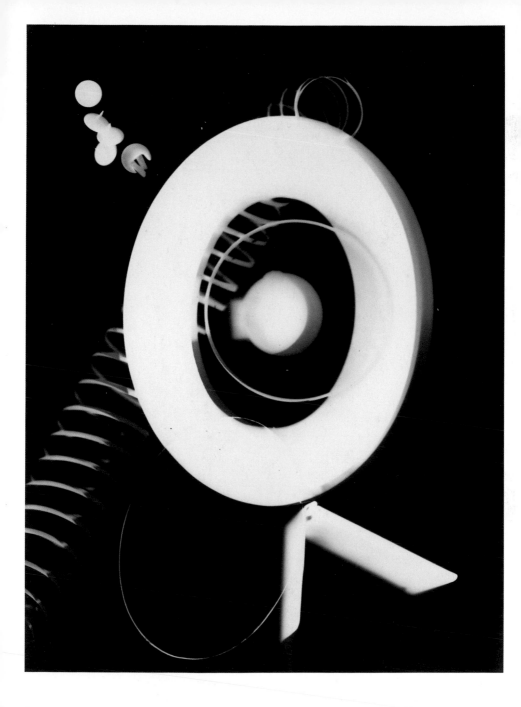

Rayograph, 1922

'I've finally figured out what's wrong with photography. It's a one-eyed man looking through a little 'ole. Now, how much reality can there be in that?'

David Hockney

B: 1937 / **N:** British / **G:** Fine art

David Hockney's gripe with photography stems from the fact that cameras limit our view of the world. Their frame and single lens create a wholly unnatural way of seeing; the photographer's peripheral vision is closed off, space is flattened and the resulting images show only one angle of a subject at one specific point in time. Put like that, photography would seem to have some issues when it comes to representing reality.

This inherent 'limitation' of photography was something that Hockney explored in the 1980s with his photographic 'joiners', in which he collaged together multiple images of the same subject taken from different angles. More recently Hockney has combined photographs, using digital technology to create what he calls 'photographic drawings'. While we recognize this image as a photograph, it's immediately apparent that something isn't quite right. The room is distorted so that we perceive it from multiple angles, the perspective of the chairs recedes to different vanishing points, the focus seems unusually deep and the man in the foreground appears to be looking at the girl, yet is somehow not. Here, the conventions of space and time that we have come to expect from photography have been entirely disrupted. For Hockney, this starts to edge closer to the experience of human vision.

The Studio Meeting, 2015

'A photograph is usually looked at – seldom looked into.'

Ansel Adams

B: 1902 / **N:** American / **G:** Landscape

For Ansel Adams, a physical photograph, like a painting, should be regarded as an art object of supreme craftsmanship in its own right. The difference between photographs and paintings, however, is that we tend to instinctively look 'at' photographs for what they depict. In effect, it's very easy for them to simply become stand-ins for the actual subject or take on the role of an invisible vessel.

Adams overcame this through sheer technical mastery. He used the sharpest lenses, he waited days for the light to be just right, he invented the 'zone system' to calculate the optimal exposure and his rigorous darkroom methods created prints of supreme tonal range. Fascinatingly, this obsessive pursuit of clarity and detail resulted in physical photographs that didn't just rival the beauty of nature – they beat it. In the case of this, one of his most iconic photographs of Snake River, the precise composition, textural sky and control over tones create a highly seductive and romanticized version of reality. Never mind the hand of God – when we look 'into' this photograph, we are presented with the hand of Ansel Adams.

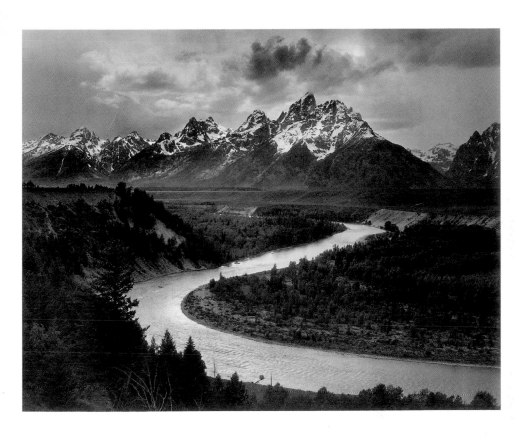

The Tetons and the Snake River,
Grand Teton National Park,
Wyoming, 1942

Untitled *(#0334),*
St Petersburg, Russia, 2008

'Photos don't get better when they're bigger.'

Hellen van Meene

B: 1972 / **N:** Dutch / **G:** Portraiture

Size has a profound impact on how we relate to photographs. After everything is done, the same photograph can be printed so small that it fits into a wallet or so big that it fills an entire wall. How, then, do photographers know how big or small to print their pictures? Hellen van Meene reminds us that a photograph's size is an extension of its concept.

Influenced by the 'quietness' of Dutch painting, van Meene uses natural light and domestic settings to photograph adolescent girls who appear lost in thought. She then prints her photographs small (around 28 centimetres/11 inches) because she wants to draw us in, she wants us to physically stand closer, she wants us to have a private encounter so that we feel the introspection of her subjects. If her photographs were larger, we would interact with them very differently. We would need to stand back, it would be hard to take everything in all at once and the viewing experience would likely be shared with others; the physical photographs themselves would conflict with the subject matter and the meaning or mood the photographer is trying to convey.

'I take photographs not only with my eyes, but with my entire body.'

Daidō Moriyama

B: 1938 / **N:** Japanese / **G:** Street

Street photographers like Daidō Moriyama 'feel' what they are seeing. This feeling doesn't just come from sight. It comes from an awareness of what all their senses are telling them. Like this stray dog with which he so identifies, Moriyama wanders streets with no fixed destination. Armed only with his compact camera, he is guided by smells and sounds, as well as by his eyes. He'll find himself off the main drags and down back alleys scavenging for moments to satisfy his visual hunger. All that matters is to point and shoot. The cleanness of the kill – focus, exposure, composition – are unimportant. By adopting such a multi-sensory approach, Moriyama manages to immerse himself in the psyche of the streets to capture viscerally raw pictures that expose the churning underbelly of Japan's most kinetic cities.

TOP: *Stray Dog*, 1971

BOTTOM: *Record No. 6*, 2000

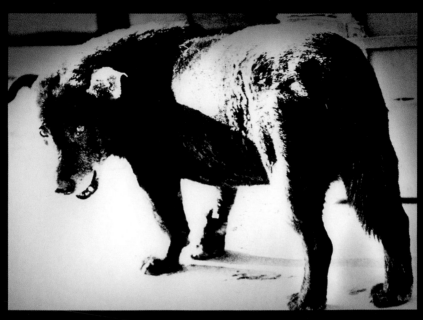

'The more conscious I am of why I'm taking it, the less successful the picture turns out to be.'

Fay Godwin

B: 1931 / **N:** British / **G:** Landscape

Even for landscape photographers like Fay Godwin, who have time to slow down and contemplate what they are seeing, it seems that overthinking is best avoided. I imagine the only thing running through Godwin's mind in the lead-up to this exposure was, *there's something about that mountain, there's something about that cloud.* This is often the level at which a landscape photographer's conscious mind is operating, because to capture that elusive *something* means trusting, rather than questioning, their intuition.

Perhaps it was only afterwards in the darkroom that Godwin could fully articulate exactly what she was responding to at the time of exposure. In this case, it was the contrast between the mountain – dark, solid, permanent – and the cloud – white, weightless and ephemeral. Yet when it becomes apparent that the mountain is, in fact, flat, the billowing cloud lends it the perfect peak. The *something* that Godwin saw was two opposites of nature that, for a few moments, became totally dependent on each other.

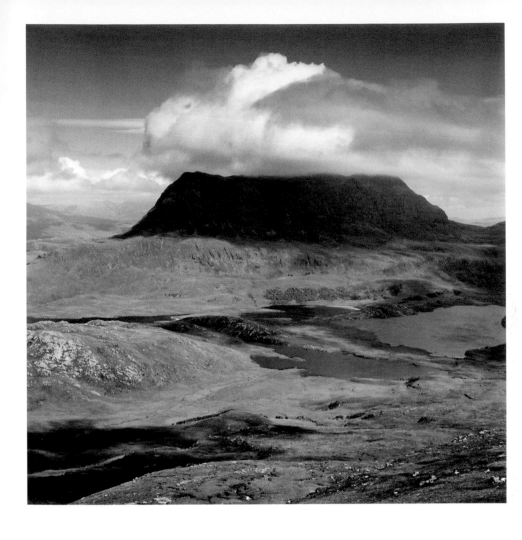

*Cùl Mòr from Stac Pollaidh, in
the Assynt Region of Sutherland,
Highland*, 1985

'It's way more important to know how to take a picture than to use a camera.'

Olivia Bee

B: 1994 / **N**: American / **G:** Reportage, fashion

Her currency is the beauty of imperfection, the rawness of blur, the fogginess of grain and the energy of an off-kilter composition. In that visual hinterland between clarity and confusion, Olivia Bee captures the emotional spectrum of youth; those ups and downs, that vagabond spirit and the mental and physical growing pains we have all experienced at one point or another.

These are human qualities that are hard to express through photography if everything is 'correct'. The problem, however, is that cameras are perfectionists. Everything about their design and function is intended to help the user create 'perfect pictures' and new technology constantly sells us improved image quality. That's why, like so many emerging photographers, Bee prefers to work with the emotiveness of film rather than the exactitude of digital. In so doing, she embraces risk and challenges the notion that good photography should be technically flawless photography.

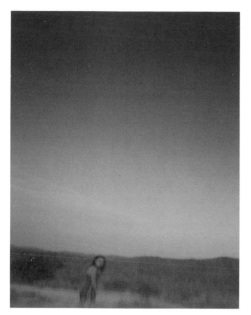

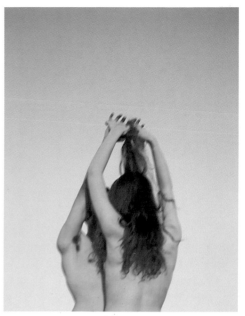

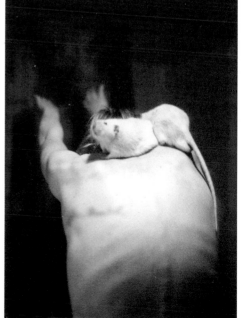

ABOVE LEFT:
California Mirage, 2015

ABOVE RIGHT:
Gold Rush, 2014

RIGHT:
Tuesday, Turnip and Dan, 2015

OLIVIA BEE

'Photographing a moment helps me move on from it, but keep it for ever.'

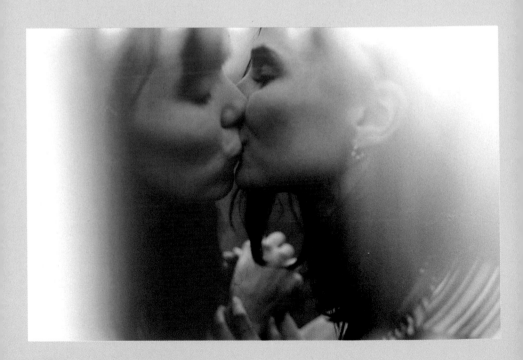

What does it feel like, for you, to take a picture of someone you love?

It feels like an extension of that love. When I take someone's photograph, our entire past together is present. Trust makes pictures. But there's also this thing of not romanticizing the love I experience with others through photography. These are real people, real relationships, not characters, not content.

When I look at your pictures of young people on the cusp of adulthood, I feel like photography is as much about letting go of something as it is about preserving a memory. Is that something you're conscious of when shooting?

I think that's definitely something I am conscious of when I'm editing; once I start to see the patterns my current work is following, the path it is taking, I'm able to see the letting go and the preservation. But when I am taking pictures, I just follow my instincts and see where they lead. I often don't know where they are leading until I see them all together, working towards some common emotional world.

When I released my book, *Kids in Love*, it came with an intense sense of mourning. When friends around the world were calling me or emailing me saying they were stoked to have my book in their hands, I felt excited, of course, but also an intense loss of the photos I had held so close for so long, and inherently, my youth, which I had held so close for so long. I had to let go of how I had preserved it. It was a beautiful feeling, holding it close, then giving it away. It was essential for my own growth as an artist and as a person.

Photographing a moment helps me move on from it, but keep it for ever.

As a photographer who records everyday moments, you must often find yourself torn between being an active participant and a separated observer. How does photography/ the camera affect your sense of the 'here

Briley and Leslie (Love in All Our Colors), 2016

27

and now'? Does it bring you closer into the moment or distance you from it?

I definitely have to be conscious about my balance between being present and being a witness. I make sure that I can be both. With the pictures I took when I was younger, of us running around like dumb kids, people often ask if I was sad not to be a part of it. But I was still running around like a dumb kid, but documenting it was my way of being a part of it.

When you were a regular teenager taking pictures of friends, I imagine they were like: *'That's cool, Olivia just takes pictures. Whatever.'* **But now that you're well known and your pictures get seen by so many eyes, has this changed the dynamic between you and the subjects you are closest to? For example, has it introduced a heightened element of self-consciousness?**

Of course, I mean that's the reality of gaining an audience. I wonder if I would make better pictures if I didn't have an audience … I guess I will never know. My intentions in my personal work are still the same as when I began taking pictures. It's how I process my life … even as the stories I photograph become more narrative, it's an interpretation of my story.

I guess I see it most when I photograph my brother. I've been photographing him since he was seven or eight. When I come home to Portland, we always make pictures. He likes it (at least he tells me he does), and I think it's cool for him to be able to see how he has grown. It's a collaboration as well; always asking him what he wants to do in the picture after I've run out of things I feel the need to document. He's more willing than when he was nine. Someday there will be a Max book.

Some of the people I grew up taking photographs of incessantly I don't photograph as much any more. But I feel like when I want to, it's still okay. Things in your hometown shift.

People who are new subjects/friends/ lovers of mine, there is an understanding. If we are friends we will usually be each other's muses in whatever way that entails, but I ask before I take the first photo, and ask before publishing something vulnerable. A lot of personal pictures from the last two years I haven't published. They're still too close to me, close to the subject.

As you're someone in her early twenties who has grown up with digital, camera phones and image sharing, I'm very curious to know what photography means to you and if it's profoundly different to older generations.

In my generation, everything is documented. It's harder to make images special, worthwhile. In the privileged Western world, nearly everyone has a camera. Everyone's visual literacy has gone through the roof. We see thousands of images on a daily basis. It's easier to dismiss images. We see a lot of the same shit over and over. One hundred different people Instagramming the same concert, a thousand ads a day … we're so immune to images. So when an image affects you, when it sticks, that is really something.

What's your favourite quotation on photography and why?

'… The camera is therefore an eye
capable of looking forward and backward
at the same time.
Forwards, it does in fact 'shoot a picture',
backwards, it records a vague shadow,
sort of an x-ray of the photographer's mind,
by looking straight through his (or her) eye
to the bottom of his (or her) soul.
Yes, forwards, a camera sees its subject,
backwards it sees the wish
to capture this particular subject
in the first place,
thereby showing simultaneously
THE THINGS
and THE DESIRE for them.
…

If, thus, a camera shoots in two directions,
forwards and backwards,
merging both pictures
so that the "back" dissolves the "front",
it allows the photographer
at the very moment of shooting
to be in front with the subjects,
rather than separated from them.
Through the "viewfinder"
the viewer can step out of his shell
to be "on the other side"
of the world,
and thereby remember better,
understand better,
see better,
hear better,
and love more deeply, too ...'

Wim Wenders

This passage, from Wim Wender's book *Once*,
represents a kind of appreciation for those
who photograph, rather than telling people
they should be there and be a witness to the
moment (which is definitely valid). I think
people often see photography as only seeing
the surface, and exploiting our lives, our loves,
but Wenders talks about photography helping
you love more deeply. How beautiful is that?

OLIVIA BEE
Originally from Portland, Olivia
Bee is now based in New York and
Los Angeles. Olivia is a film-maker
and photographer who has shot
campaigns for many leading
international brands. Her personal
work culminated in a book, *Kids
in Love*, which was published by
Aperture in 2016.

'Reality is to photography what melody is to music.'

Ralph Gibson

B: 1939 / **N:** American / **G:** Portraiture, fashion, fine art

This association comes from a man as committed to the guitar as he is to the camera. While Gibson's work has always teetered on the fringes of abstraction, typically using high-contrast black and white but more recently colour, it never slips into total abstraction. To leave the viewer in a state of not being able to decipher the literal content of the photograph would mean abandoning what is, for Gibson, one of photography's most distinctive attributes: clarity.

For his recent series, 'The Vertical Horizon', Gibson exploits the abstract qualities of the portrait format. Unlike landscape format (which, until the introduction of camera phones, was photography's 'default' format), a vertical picture tends to be less dependent on established compositional rules. His pictures, taken in Europe, Asia, South America and the US, are both abstract and representational. By treading this fine centreline, Gibson removes any recognizable cultural signifiers in terms of revealing where the individual photographs were taken, while at the same time leaves no ambiguity about what the pictures are of. In these tightly controlled rectangular arrangements, we piece together a globalized world that is fast becoming visually unified.

Untitled, from the series 'The Vertical Horizon', 2016

'I go out to take a walk, I see something, I take a picture. I take photographs.'

Saul Leiter

B: 1923 / **N:** American / **G:** Street

For Saul Leiter, heading out with his camera was no big deal. It was just something he did, every day, without personal pressure or expectations. He didn't cover huge distances – but then again, when downtown New York is your shooting ground you don't need to. Leiter would amble from street to street, from avenue to avenue, only stopping occasionally to take a picture when an abstract observation caught his eye. Sometimes he returned home with nothing. Other times he won big, like the day he peered into an empty train carriage and spotted a simple foot resting on a seat.

Looking at the picture, there's the colour palette, the compositional zigzagging and the positioning of the shoe. That's all perfect, but the real beauty comes from something else. It's the lightness of touch and apparent effortlessness of a honed eye. It's the way the picture totally encapsulates Leiter's uncomplicated attitude to photography. He sees something. He takes a picture. In that moment, he never stops to ask himself why.

Foot on El, 1954

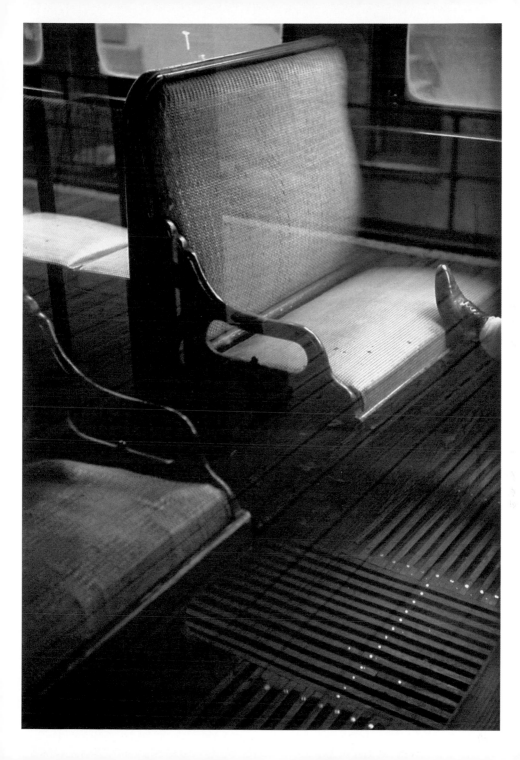

Untitled #6405–8, 2007

'There are no rules. But sometimes you need parameters.'

Todd Hido

B: 1968 / **N:** American / **G:** Landscape, portraiture, interiors

Here Todd Hido reminds us that too much creative freedom can lead to incoherence, while too tight a brief can be stifling. For his 'Landscape' series, Hido made painterly photographs of beautifully bleak roadside scenes shot through the misty windows of his car. Photographing through the moisture blurs the boundary between what's near and far, between what's inside and outside. The glass acts as both a window and a screen, creating images layered with metaphorical clarity and confusion.

Hido decided that he would always shoot from the car, it would always be during winter and the locations would always be nondescript. Other elements such as the time of day, subject matter, colour palette and weather conditions were left open. Those formed his 'parameters' – tight enough to focus his creativity, loose enough to allow for unexpected encounters.

'What's the point of taking a nice picture?'

Maisie Cousins

B: 1993 / **N:** British / **G:** Still life

No matter what she says, Maisie Cousins does take nice pictures – just not the kind your granny might consider to be 'nice'. This glossily grotesque photograph is both repulsive and intensely seductive. Emerging from the mash-up of shrimp heads, cut flowers and god knows what else is a distinctly girly colour palate. And when accompanied by the series title, 'What Girls Are Made Of', it becomes a playfully direct depiction of femininity.

Nice pictures, the kind we see in fashion and lifestyle magazines, are not challenging. They tend to reinforce stereotypes and tell us things we already know; this place is beautiful or that person is pretty. For Cousins, this approach to photography is unhealthily inoffensive and misrepresentative of who or what we are. In particular, her stance against conventional niceness in photography is a rejection of how women have been represented in the past. Rather than aim to idealize individuals for their surface beauty, Cousins reminds us that we are all products of nature. Regardless of looks, you, me and Taylor Swift are just lumps of meat kept alive by an acidic concoction of bodily fluids. If that's the undeniable truth, then what is the point of taking a nice picture?

Untitled, from the series 'What Girls Are Made Of', 2013–14

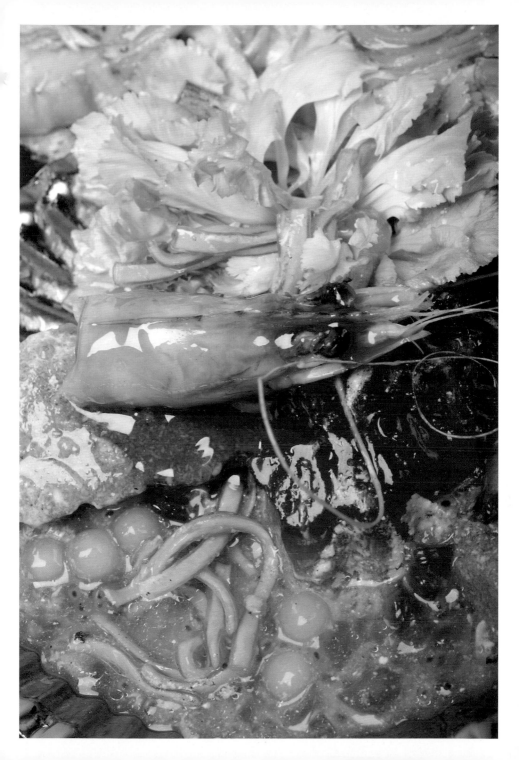

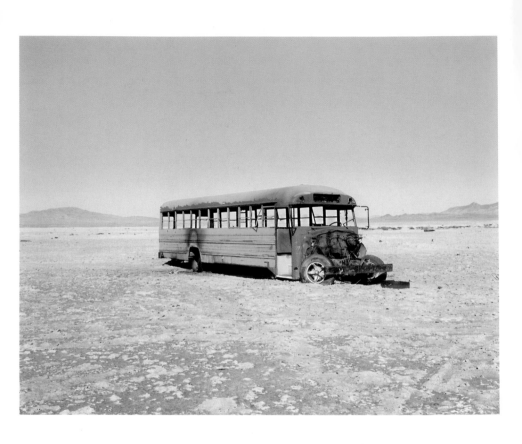

Personnel Carrier Painted to Simulate School Bus, from the series 'Desert Cantos', 1986

'I've come to believe that beauty can be a very powerful conveyor of difficult ideas. It engages people when they might otherwise look away.'

Richard Misrach

B: 1949 / **N:** American / **G:** Landscape

Beauty and photography have a complicated relationship. There are photographers who are content to make pretty pictures that are appreciated momentarily for their surface beauty. Then there are other photographers, like Richard Misrach, who use beauty to ask more of their audience. Yet this is difficult territory because, if handled wrongly, the seductive look of a work can add a layer of superficiality that dilutes its meaning.

Misrach's 'Desert Cantos' series is undeniably beautiful. His compositions are classic: he photographs when the light is best and his large prints are pin sharp and rich with detail. However, he overlays this aesthetic on subject matter that would typically challenge our notions of beauty. Here we see the wreckage of what looks like an American school bus in a desert landscape. But this isn't the aftermath of a homeland attack. In a perverse twist, the only aggressor here is the US military, who used this symbol of American values for target practice in the Nevada Desert. For Misrach, the most effective use of beauty is to reflect on ugliness.

'I don't know whether we will have the same level of emotional longing for a digital iPhone picture as we will have for a gelatin-silver print.'

Tacita Dean

B: 1965 / **N:** British / **G:** Fine art

A cloud can't be touched, its exact shape is constantly changing and, if it is an object at all, it is one that can never be owned. So for Tacita Dean to photograph a cloud, print it on photographic paper and then meticulously paint around its edge fulfils a desire to give physicality to one of the most ephemeral of subjects.

That emotional longing for the physicality of things lies at the heart of Dean's reflections about the changing nature of photographs. A printed photograph, particularly one resulting from a film negative, is precious because it asks to be handled delicately. A digital image, however, is called into existence and then dismissed with a click or a swipe. And while the raw materials of a physical photograph can contain silver or platinum, a digital image is just code.

All that said, Dean is not claiming the death of photography; she is simply highlighting that we are entering a new and uncharted era, one in which photographs are saved rather than savoured. And in the case of some photo-sharing apps, photographs are no longer even saved. Instead, they have pre-programmed lifespans causing them to live and die before our eyes in a matter of moments. Compare that to ripping up a printed photograph, which is akin to an act of violence

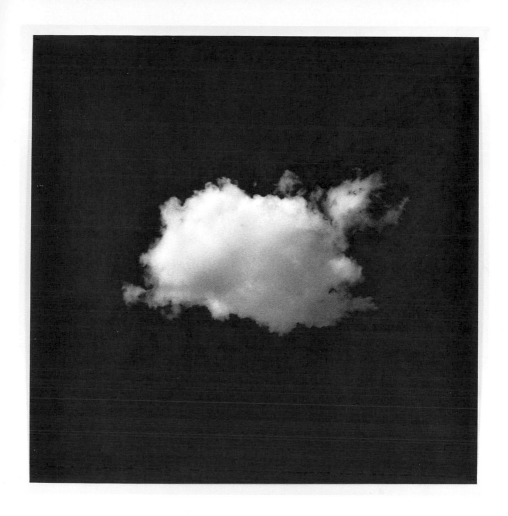

Veteran Too, from the series
'A Concordance of Fifty
American Clouds', 2016

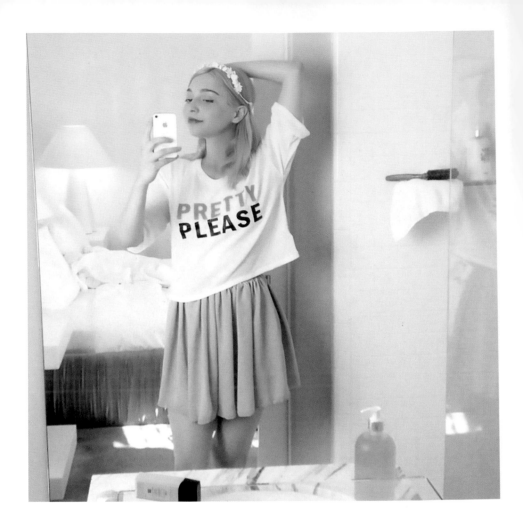

Untitled, from the series
'Excellences & Perfections', 2015
[Instagram Upload, 1 June 2014]

'How do we consume images or how do they consume us?'

Amalia Ulman

B: 1989 / **N:** Argentine-Spanish / **G:** Self-portraiture, installation, digital media

Using her existing Instagram account (@amaliaulman), Amalia Ulman began acting out the tragic story of a fictitious alter ego. Through the images on her feed, we saw Ulman supposedly break up with her boyfriend, move to LA, find a sugar daddy, undergo cosmetic surgery and become suicidal before finding salvation in the arms of a good man. Unaware that this was all an elaborately scripted performance, followers liked and commented on Ulman's pictures, apparently revelling in her spiralling descent into a state of narcissistic desperation.

Ulman's work reveals a disturbing truth about how the majority of people use and consume photography. By taking selfies and sharing them online, photography has given us what we all yearn for: an identity. Only, the identity it has given us isn't ours. To a greater or lesser extent, it is a made-up character, someone we have created to be 'liked', envied and, in extreme cases, bought by brands. It means that, as a communication tool, photography is more powerful than ever because it has turned us all into marketers – and the product being sold is ourselves.

'Photography creates a desire.'

Alison Jackson

B: 1970 / **N:** British / **G:** Portraiture

Alison Jackson presents a comically absurd alternative reality to the already comically absurd alternative reality of celebrity culture. Using lookalikes, Jackson stages fictitious scenarios that push the 'image' of a particular celebrity to the extreme. What's most revealing, however, is that her pictures continue to hold a strange allure, even when we know they are fake. It's as if we want, or need, to keep believing in what we are seeing.

For Jackson, photographs are like a drug to which society has become addicted. In terms of celebrities, they offer tasters into the lives of people who, for most of us, will only ever exist as images. This emotional bond that we develop with strangers through their image highlights the unique power of photographs; photographs give us something while at the same time give us nothing. It's a classic case of being offered a taste – or more accurately, a trace – of something we want but can never have.

Wills Tries Crown on Kate, 2011

'Photographing people is a collaboration, a threesome even, the camera being the third party.'

Harley Weir

B: 1988 / **N:** British / **G:** Fashion and portraiture

Few inanimate objects have such a dramatic physical and psychological effect on people as the camera. It's like a gun in that respect, loaded with the unseen eyes of an audience, eyes that will ultimately cast judgement in one form or another. It's not surprising, then, that a photographer like Harley Weir, who takes intimate photographs of women, is well aware of the camera's voyeuristic connotations and the effect this has on her subjects. It's something we can begin to feel here, when looking at this photographic ménage à trois.

With her clearly defined shadow being cast on the model, Weir puts herself in the picture and becomes very much part of the performance. This splitting of the photographer's presence, or position, heightens our awareness of our own gaze. We're no longer passively seeing through the eyes of the photographer and instead observe both parties in front of us, while at the same time finding ourselves between them. There's a perculiar sense that we are 'the third party'. Rather than seeing through the eyes of the photographer, it's as if we are in, or we are, the camera.

September, 2016

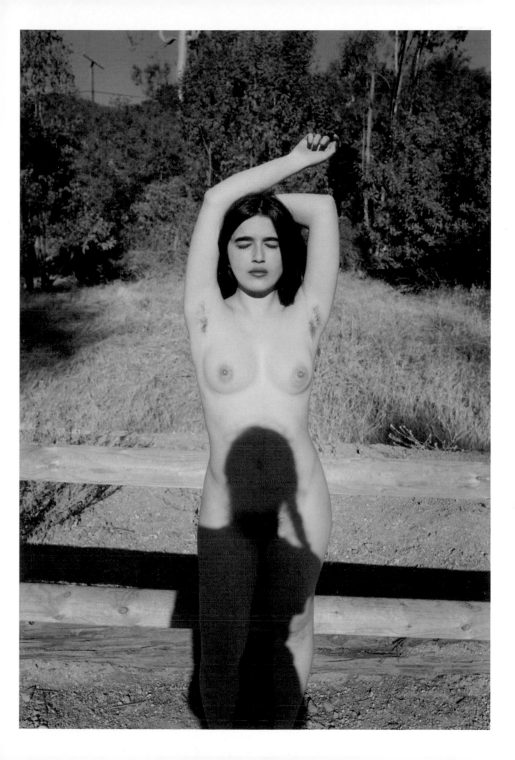

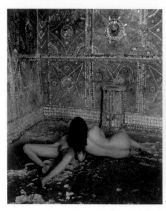

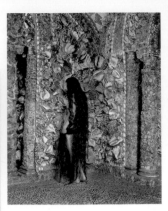

Untitled, from the series 'Heavy
the Sea', 2012/2017

'It feels like my body has disappeared and I have become a part of the picture, a part of the camera.'

Esther Teichmann

B: 1980 / **N:** German-American / **G:** Fine art

Esther Teichman's photographs present a vaporous lost world in which people exist in a state of mental and physical inertia surrounded by exotic flora and enveloping caves. As we peer through the musky colour palettes, familiar objects such as shells, rocks and water take on more carnal connotations. It all feels like the fleeting recollections of a deep sleep or a glimpse into our own unfathomable psyche, a place our conscious mind chooses to suppress.

To create such an immersive world in pictures, Teichmann adopts a more visceral, rather than cerebral, process. In the same way that a pianist doesn't consciously think about which keys to press next, a photographer doesn't consciously think about every single adjustment they make to the camera or set-up. By allowing her mind to leave the conscious state, a state where logical thoughts override her instinctual responses, Teichmann becomes unrestricted by her physical self and the otherness of the instrument.

'Things usually don't develop quite as imagined, but that often leads to the best work.'

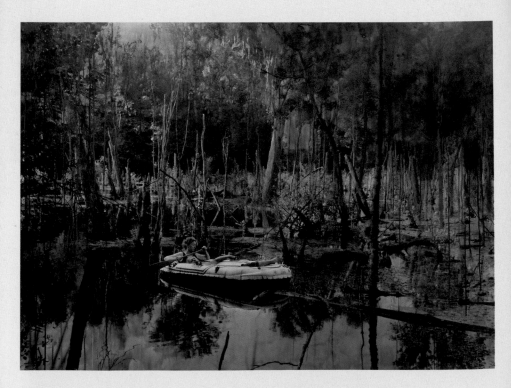

I can imagine a painter or sculptor saying that they 'forget their body' because, to make their work, they either don't need tools or the tools are very simple. But as a photographer, how do you manage to get past the conscious awareness of operating the camera, which is such a complex and technical 'tool'?

Mostly by preparing prior to shoots – for example, if working in my studio with a set build or backdrop set-up, I'll work on lighting and framing and have all camera formats set up in advance. Then on shoot there are always changes, of course, but I am not worrying about the technical aspects, and can just be fully absorbed in looking at and for the image. It is a combination of intense concentration on the image, working silently but in a focused way with my subject, and being as precise as possible technically. Of course, I still make 'mistakes' all the time and things usually don't develop quite as imagined, but that often leads to the best work.

Untitled, from the series
'Mythologies', 2009

Your subject matter and your picture-taking process must mean that you have a very intimate relationship with your photographs, one that the viewer could never have. How does your memory of the picture-taking act affect the editing process?

The two aspects of making an image converge and turn into something else – a kind of imaginary picture. It is hard to put into words what the intimacy of shooting can feel like. I often leave time between the shooting and editing to be able to see the pictures without thinking about the making of them, but to be honest I usually know immediately, as soon as I see the negatives, before I even print them, which one I will use.

In terms of how your work evolves from series to series, what's the balance between making strategic career choices versus relying on your purely creative desires?

In a sense, I don't actually work in series, which is perhaps unusual for the medium. My work is more of an unfolding, a circling around ongoing themes, using new ways of working to tell stories. I am not sure I think about strategic career choices in relation to the process of making, or hope I don't – the making is rather informed by what excites and inspires me, more impulsive than rational or strategic. Strategic decisions are more of a factor when perhaps researching where and in what context to show and publish the work and how this affects the understanding and reading thereof.

Are your pictures a collaboration between you and your subject, or are you secretly just manipulating them to do what you want?

That question made me laugh. But it's an important one. Fundamentally I have an idea, often more of a feeling than visual clarity. I know what I want a picture to feel like, what I want it to evoke and perhaps other existing work of mine I want it to resonate with or extend from. I am drawn to subjects, whether familiar or strangers, who somehow affect me, and with whom I think I can create the picture I imagined. Often they are stand-ins for myself in some way, embodying in gesture or emotion what I want to convey. There is an intensity to the process that depends on an openness and generosity on the part of the subject – a willingness to become what I need them to be for the picture. So, in some senses it is collaborative, but more in the sense that it requires a giving up of the self on the part of my subject. There is an absolute presence during this strange disappearance on both our parts, which is different to any other encounter.

As you have a fairly clear mental image of the photograph you want to create, do you ever end up with something you weren't expecting?

Often what I want to evoke manifests itself most powerfully in a very different form than I imagined – that is what is so incredible and exciting about the process. It takes me somewhere that I didn't know before. And that new work in turn leads me onwards to another place and picture. It is kind of like this journey which I am in part directing, and in other ways am entirely led by.

Are your reasons for taking pictures any different now to when you started?

I don't think so, no. Without sounding overly romantic or melodramatic, it is what makes me happiest or perhaps rather, most alive and myself. I get anxious and feel disconnected when I am not thinking about this other world of pictures and stories. It's never finished or complete or quite right, but you get a sense of what it could become, how the parts might fit together, so you keep building upon and reworking what has been made with new work.

As an art school lecturer, you must encounter hundreds of aspiring photographers. Over the years, have you noticed any traits that suggest why some people make it and others don't?

Consistent hard work is really central to all success, as is believing in your work (whilst being self-critical). Continually push yourself beyond what is known or comfortable, whilst never losing sight of what is at the core of your practice. Learn to say no to that which does not feel right or seems like it will take you in the direction you don't want to go, as focus is crucial to not losing momentum. Surround yourself with people who inspire you and who are open and generous, and in turn be generous yourself in supporting others.

There is also the question of talent, but

I think 'talent' is hard to define; we know when we encounter it, when a work surprises and excites us and feels like we have not experienced or seen something quite like it. 'Talent' is subjective and can mean many things, and of course is not in any way necessarily connected to success, whilst hopefully usually a factor therein.

The prevailing history of photography is very male dominated. Even today, there are very few women who sit alongside the likes of Annie Leibovitz. Is there some kind of underlying social or industry structure in place that suppresses female photographers?

Unfortunately, yes, in all aspects of the field, from fine art to fashion and advertising photography, women are less represented than their male counterparts, even though there are more female students studying photography than male. Like in most other aspects of contemporary society there are multiple interconnected reasons for this, but what is exciting is a new generation of female photographers who are becoming incredibly politically active and are pushing against these systematic structures of oppression and are finding new ways to be seen and heard. It is also an exciting moment when, in reaction to regressive political power, the creative industry as a whole is rethinking its history, which has excluded many voices, and is now revisiting those incredible figures who have been overlooked and forgotten.

What's your favourite quotation on photography?

The photographer Richard Avedon describes his first encounter with the photographic as one of branding and imprinting an image of desire onto his own skin — a violent, tender and carnal response to the medium. In his autobiographical essay, 'Borrowed Dogs' [see *Richard Avedon Portraits*. New York: Harry N. Abrahams, 2002], he tells of a photographic tattooing, of burning an image of his muse, his sister, onto his body.

He writes: 'It was my father who taught me the physics of photography. When I was a boy he explained to me the power of light in the making of a photograph. He held a magnifying glass between the sun and a leaf and set the leaf on fire. The next day, as an experiment, I taped a negative of my sister onto my skin and spent the day at Atlantic Beach. That night, when I peeled the negative off, there was my sister, sunburned onto my shoulder.'

ESTHER TEICHMANN
Living and working in London, Esther Teichmann is an artist and academic. She has an MA and PhD from the Royal College of Art and her multidisciplinary work includes photography, moving image, writing and curating. Esther is currently working on a monograph of visual works and essays, entitled *Fulmine*.

'When you put four edges around some facts, you change those facts.'

Garry Winograd

B: 1928 / **N:** American / **G:** Street

To use a recently coined term, presenting 'alternative facts' is what photographs and photographers do best. For instance, what does Garry Winogrand's photograph show? A relaxed young couple holding two chimps? Or an anxious, *mixed-race* couple holding two chimps?

Winogrand knew exactly what he was doing when he framed this couple. And 'framed' they were, because Winogrand was making a statement that his subjects were not necessarily party to in real life. In this case, he exploited the frozen moment and isolating nature of the frame to create a contentious image that raised difficult questions about race.

Winogrand himself was not being judgemental. His intention was to shift the role of judgement to the viewer by making them reflect on their own gaze and social prejudices. And remember this was 1967, a time when interracial relationships were still 'noticed'. Especially by the playfully provocative eye of a photographer like Winogrand.

Central Park Zoo, New York City, 1967

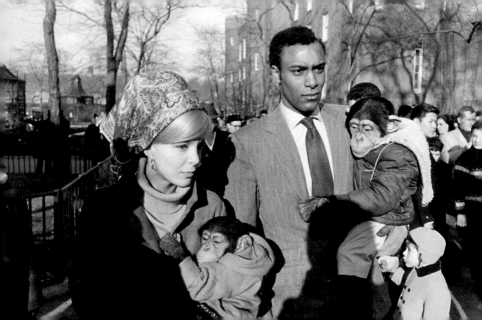

'When a person looks at a photograph you've taken, they will always think of themselves.'

Jason Fulford

B: 1973 / **N:** American / **G:** Fine art

These pictures from Jason Fulford's playfully titled book *Raising Frogs for $$$* show specific subjects, yet it is left up to us to ascertain their possible meaning and connections. It's like a game in which players draw on their own personal history to make sense of the clues they are offered. Ultimately, this means the photographs have no fixed meaning.

For Fulford, a photograph is similar to a psychologist's inkblot because, right after we interpret the literal aspects of the image (which in these photographs are the sky, tree, chairs and so on), we enter into a second, much more personal reading. This second reading is informed by elements such as our memories, personal experiences, tastes and cultural background. In other words, the first reading is based on what the photograph imposes on us and the second is based on what we impose on the photograph. As we are all different, this second reading is unpredictable and entirely outside of the photographer's control. For Fulford, this gap between what is pictured and what it might mean is where photographs come alive.

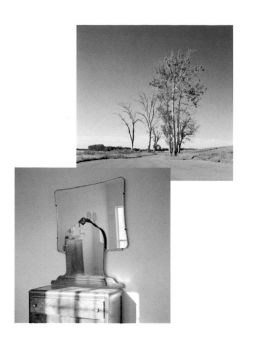
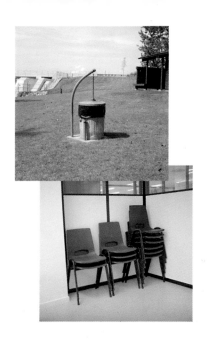

Page from *Raising Frogs for \$\$\$*, 2006

5 (Degradé), 2001

'It's not that I don't care about content, but content is not the only way a photograph has meaning.'

James Welling

B: 1951 / **N:** American / **G:** Fine art

Because James Welling's work is a photograph, we expect it to show us something literal. We can't help but see a horizon line separating land from sky. With that yellowy green and plum purple, perhaps it's a lush Tuscan field under a blazing sunset. Perhaps that wisp of grey is the sunlight reflecting off the distant ocean.

Welling's photograph is, in fact, of nothing. The product of light projected through coloured filters directly onto photosensitive paper, this is a one-off photograph. It is not made from a negative or digital file, there is no frozen moment, no direct trace from the world and no subject; it is without content. While captured light is still its main ingredient, here Welling creates something entirely abstract that breaks photography from its representative responsibilities and temporal ties. In so doing, he causes us to reconsider what we have come to demand from photography — subject matter — and challenges the notion that a photograph has to be 'of' anything at all.

'Photography is the easiest art, which perhaps makes it the hardest.'

Lisette Model

B: 1901 / **N:** Austrian-American / **G:** Street

Let there be no doubt about it, photography is easy. Anyone can take a photo. Anyone can take a good photo. Anyone can take a great photo. That's if we assume, as most of the population does, that a great photo should be in focus, well exposed and show a pretty subject. Lisette Model, however, didn't subscribe to that definition of 'great'. Her gritty street photographs taken in the 1940s were direct and in close, depicting working-class and destitute subjects that polite society of the time preferred to overlook. With full and characterful compositions that captured tender, expressive and socially pointed New York moments, Model achieved the hardest thing of all with the easiest of arts. She showed how a medium so adept at recording the surface of society can, in fact, be used to reveal the humanity of what lies beneath.

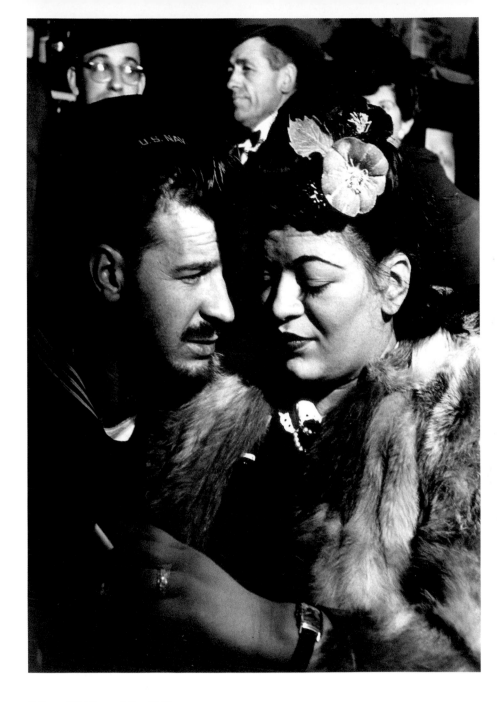

Sailor and Girl, Sammy's Bar, 1940

'The photography I most respect pulls something out of the ether of nothingness.'

Paul Graham

B: 1956 / **N:** English / **G:** Street, fine art

A black man mows the grass as it starts to rain. Canned goods sit on sparsely stocked shelves. A stranger walks down the street en route to nowhere. A blazing sunset. People wait for the lights to change. A bird flies overhead. An elderly white woman collects her mail at the bottom of her driveway. A Hispanic man walks past a cat. And then points to something. Black kids play basketball on a suburban street. The moon rises over a gas station.

These are some of the photographic glimpses Paul Graham offers us in 'a shimmer of possibility', a photo essay about modern America that weaves together unrelated encounters and observations. Counter to photography's usual function, Graham doesn't point his camera at anything that would appear worth remembering, such as this sequence which fixates on a man taking a cigarette break. However, by peering into this 'ether of nothingness', Graham reveals a prosaic profundity that memorializes moments that we can all relate to. The kind of everyday moments when something or someone, for whatever reason, catches our eye. The moments that we mull over as we walk on by or stop to observe a little longer. The moments that we then file away in a messy corner of our mind called 'Reality'.

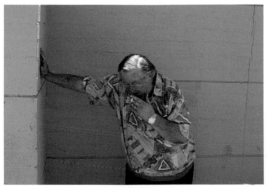
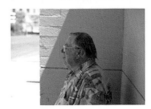
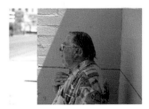

Las Vegas, from the series
'a shimmer of possibility',
2005

'You don't want to feel the artificiality of the image, you want to believe in it.'

Viviane Sassen

B: 1972 / **N:** Dutch / **G:** Fashion, fine art

Viviane Sassen's pictures offer fragmented glimpses into the mysterious otherness of Africa. Photographing under intense sun, she uses light and shadow to obscure the identities of her dark-skinned subjects. To Western eyes, people, places and actions remain ambiguous as they loiter between detail and darkness. In this picture, the subject's face is shrouded in a void of black so defined it's almost as if they have been cut out of the composition. They are both there and not there. This anonymity creates a state of separation between subject and viewer, but not to such an extent that we are entirely alienated from the image.

Ambiguity with its foothold in reality rather than artifice is exactly the line that Sassen likes to tread. She doesn't use digital post-production gimmicks, the kind that cause a photograph to slip into fakery or total invention, and instead creates visual intrigue through the purest of means: the quality of light. We are purposefully kept at a distance and unable to form any kind of relationship with the people in Sassen's pictures and yet, through the purity of technique, we're offered a way of reaching out to them.

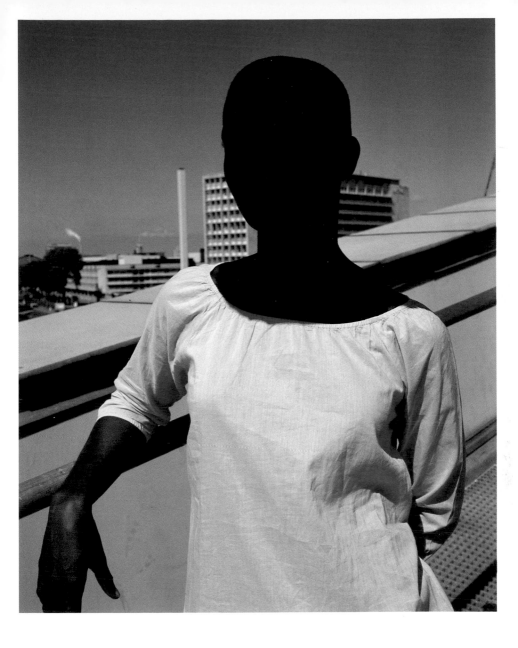

Kathleen, from the series
'Flamboya', 2000

'If you always use the same "signature" style, you end up putting too much of yourself there, while covering up the subject itself.'

Laia Abril

B: 1986 / **N:** Spanish / **G:** Fine art

For many photographers, particularly those working commercially, establishing a signature style is vital. It forms their brand and when that brand becomes so recognized, shoots become as much about the photographer as the subject. That, to put it bluntly, is great for business. However, in less commercial areas of photography, such as fine art, some photographers think about style very differently. And for Laia Abril, developing an overt signature style is something she purposefully avoids.

Here are three images from three different series by Abril. We could easily be looking at the work of three photographers: from one series to the next, Abril has adopted an entirely different style. Rather than put her stamp on the work, she is intentionally trying to remove herself. In so doing, her photographic 'ego' doesn't interfere with her intended message. Instead, this helps the viewer to see past the photographer and focus on the work's thematic concerns. And it's in Abril's thematic concerns where she is consistent because, as a whole, her work offers a probing insight into the important issues of female identity, sexuality and misogyny.

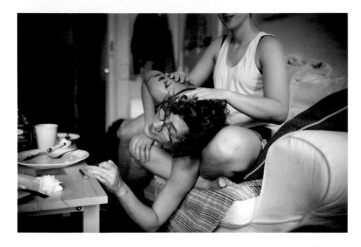

TOP:
Untitled, from the series
'Femme Love', 2009

CENTRE:
Untitled [screenshot], from the
series 'Tediousphilia', 2013

BOTTOM:
Untitled, from the series
'On Abortion', 2015

'If you ever make anything too literal, you might as well forget it. It loses everything.'

Gillian Wearing

B: 1963 / **N:** British / **G:** Fine art

In this self-portrait, Gillian Wearing is pictured in a prosthetic mask cast in the image of her childhood self. Cool idea, we might say, but that's not what causes the picture to linger in our minds. That comes from the more unexpected elements: the size of the eyeholes, the doll-like smoothness of the skin and the sinister cuteness of the tilted head. These, for reasons we can't quite explain, are the less literal aspects of the image that continue to disturb and intrigue us.

Unlike poets or painters who can 'make stuff up', photographers are totally tied to reality when it comes to their art. This issue lies at the heart of Wearing's statement, because falling into the trap of being overly literal is all too easy for photographers and taking pictures simply becomes an exercise in illustrating an idea or showing something as it is. That said, there's a danger in being purposefully obscure, too, because audiences do need something to hold on to, at least initially. This is what makes Wearing's photography so compelling; she leads us in, but then lets our imaginations off the leash.

Self-Portrait at Three Years Old,
2004

Lenny, Minneapolis, Minnesota,
from the series 'Sleeping by the
Mississippi', 2002

'If in your heart of hearts you want to take pictures of kitties, take pictures of kitties.'

Alec Soth

B: 1969 / **N:** American / **G:** Documentary

Alec Soth doesn't take pictures of kitties. Probably because, in his heart of hearts, he's not all that interested in kitties. He much prefers photographing strangers and the unfamiliar places he encounters on the road. This led Soth to Lenny. On first inspection, Lenny appears like someone you perhaps wouldn't want to mess with. But then you wonder about the evenness of his spray tan and waxed torso. And as for the décor, it all seems a little too quaint or mumsy for a knucklehead. Clearly, something's not adding up. In fact, Lenny is an erotic masseur and, in a kind of 'what the hey' moment, Soth decided to respond to his ad in the local paper. For Soth, these are the kind of subjects and situations that resonate the most, because they strike a chord with what does lie in his heart of hearts: a personal need to connect with his fellow humans and give voice to the stories that usually remain untold.

ALEC SOTH

'I fell in love with photography because it was an excuse to wander around alone.'

I recently read an interview with the photographer Nadav Kander where he said he's 'getting better and better at speaking Nadav Kander'. Can you tell us a bit about the visual language of 'Alec Soth' and how that has evolved and what influences are in the mix?

I think about photography itself as a language. Like any language, it has its various dialects and accents. But just as it isn't the job of a writer to create a new written language, it isn't the job of a photographer to create a new visual language. Maybe I had some sort of desire to do that when I was 22, but I quickly learned that such ambition is folly. To speak your own language is to talk only to yourself. I don't spend much time analyzing my own dialect and accent. Instead of focusing on that, I just try to sing.

Untitled, from the series
'Looking for Love', 1996

Stylistically you appear to work quite cyclically. Your use of flash and black and white in 'Looking for Love' is very different to the natural lighting and use of colour in 'Sleeping by the Mississippi', but then 'Songbook' looks more like 'Looking for Love'. This means that it's quite hard to pin down exactly what an Alec Soth picture looks like or what might be coming next. Is there a strategy somewhere in that?

Photography is inextricably linked to technology. There's no getting around that. But I'm not terribly interested in defining an individual photographer by the usage of a particular piece of technology. I've always envied film-makers in this regard. Martin Scorsese can shoot on black-and-white film or digital video and this is of secondary interest to most viewers. Instead people connect his films thematically (New York, the mafia, masculinity, etc.). I'm not sure if this will ever be the case with photographers, but a boy can dream.

When you set out on the road, do you have a story to tell about America or do you let America tell you a story? I read somewhere that you make lists of things you'd like to photograph, for example.

I've yet to find a specific story I needed to tell. If I do, I'll likely turn to another medium like film-making. Photography is great at suggesting stories, but tends to flounder when it attempts to 'tell' them. It functions more like poetry than a novel. For me, it starts with an image or observation and takes shape over time. Other photographers are good at aimless wandering, but it doesn't work well for me. To get my attention fired up, I like to have something to look for. But the real goal is to find something unexpected along the way.

When it comes to constructing narrative, do you have a specific way of working or starting point? Would you, for example, build a series around a few key images or instead piece together images to form separate mini-narratives within the wider arc of a project?

It depends on the project. I've done dozens of small experimental projects that have taken many different forms. But for my four largest projects, I've worked over multiple years to create layered projects that shuffle a variety of subjects within a lyrical form. The goal is something closer to rhythm than a narrative arc. It's a very delicate balance. This, to me, is the biggest challenge. Anybody can make a great picture. But it's incredibly difficult to bring multiple pictures together in a way that transforms the whole into something special without diminishing the power of individual images.

Your photographs can be intimate while still offering the subject a respectful distance. Your compositions can be sparse, while communicating so much. For me, there is

warmth, but also a touch of coolness. Is this the result of a conscious or unconscious approach to taking pictures?

I know what you mean. This quality probably isn't too different than my personality. But like my personality, it isn't terribly intentional. It doesn't matter how much I want to be viewed as a bubbly extrovert, I am what I am. This seems to be the case with my photos. Wherever I go, there I am.

How do you decide how much information you share about the people, places and situations in your photographs? In the context of your books or exhibitions, generally you don't tend to tell us too much, which creates intrigue as our imaginations are taken on a journey that lead to no definite answers. However, during talks, etc. you often give extra commentary about specific images. To what extent are you careful not to reveal too much, to avoid breaking that beautiful ambiguity so inherent in your photographs?

How much to reveal? This is the never-ending question. I certainly don't have a definitive answer. I'll often present the work in different ways in different contexts to get a feel. I do care about audiences. I want to keep them engaged. But I also want to challenge them.

As a storyteller influenced by music and film, do you find photography to be liberating or frustrating? Or, to put it another way, what is it about photography that makes it your medium of choice?

That's a great question. Years ago I did a project where film-makers followed me around for months. I was jealous of their ability to tell a story, but they were jealous of my freedom. In the end, I'll take freedom. Like most people, I fell in love with photography because it was an excuse to wander around alone. Sometimes I find it problematic as

a tool for communication, but the process continues to be a pleasure.

When travelling around America you must have encountered so much beauty or subjects that could easily slip into cliché. When shooting and editing for a series, how do you judge that fine line between ambiguity and literalness, metaphor and mystique? And if you deem something to be a little trite, do you ever find yourself photographing it anyway, just for yourself?

Oh, sure, I'll take the picture! You can always edit it out later. I think it's a mistake to entirely run away from cliché. There's a danger of throwing the baby out with the bathwater. The baby is feeling. My ambition isn't to make a bunch of cool ironic pictures that look good in a loft. I want my work to dig a little deeper. That means occasionally bumping up against clichés.

It's always fascinating to see how artists and photographers choose to use Instagram. Your account, @littlebrownmushroom, offers us an everyday glimpse into your lighter, funnier side. Can you tell us a bit about what you think of Instagram, its value to you creatively and how you choose to use it?

Thanks for noticing. I try to mix humour into my artwork, but it sometimes gets a little lost in the shadow of heavy content. So it's good to have a place to be more playful. I have a little DIY enterprise called Little Brown Mushroom. I think of it as a sandbox — a place to play. I use Instagram as an extension of this. I guess it functions like a sort of sketchbook.

What's your favourite quotation on photography and why?

Like everybody, I love what Arbus said about secrets ['A picture is a secret about a secret, the more it tells you the less you know'] and Szarkowski about pointing ['One might compare the art of photography to the act of pointing'], but lately I turn to Walt Whitman when I'm looking for inspiration. He might as well have been talking about photography when he said:
'Now I wash the gum from your eyes,
You must habit yourself to the dazzle of the light and of every moment of your life'.

ALEC SOTH
Born and based in Minneapolis, Alec Soth has published over 25 books and has had over 50 solo exhibitions. Alec has also been the recipient of numerous fellowships and awards, including the Guggenheim Fellowship (2013). In 2008, Alec created Little Brown Mushroom, a multi-media enterprise focused on visual storytelling. Alec is a member of Magnum Photos.

WRONG

Wrong, 1966–1968

'Probably one of the worst things to happen to photography is that cameras have viewfinders.'

John Baldessari

B: 1931 / **N:** American / **G:** Fine art

Paradoxically, John Baldessari is suggesting that cameras can blind the user rather than help them see because the act of looking through the 'view' 'finder' becomes an exercise in conformity. With its neat, readymade frame, we are encouraged to find familiar subjects that can be easily organized in accordance with the rules we are taught. And, as illustrated in this playful work, it can be absurd to evaluate the visual language of photographs in terms of rules.

Like something we might encounter in a photography textbook, the image is accompanied by the annotation 'wrong' because the subject, Baldessari himself, is standing in front of a tree so that it appears to be growing out of his head. We could, however, think: 'Aren't the flattening effects of a photograph amazing. It gives us an entirely new perception of space!' In an ironic masterstroke, Baldessari creates an enduring artwork using visual language we're taught to reject, highlighting that there are no absolute rules when it comes to filling our viewfinders. Or, to put it another way, the only 'wrong' is to attempt to be 'right'.

'I try to take photos like an alien.'

Lars Tunbjörk

B: 1956 / **N:** Swedish / **G:** Reportage

It takes a special set of eyes to make somewhere so ordinary appear so outlandish. When Lars Tunbjörk photographed offices around the world, he homed in on the idiosyncratic details under desks and the mountains of corporate clutter surrounding chaotic workers. His pictures make the employees appear as if they are caught up in a madcap world of administrative duties. As they dash around the office and organize papers on the floor, there's a sense that the 'living' they are feverishly chasing has inadvertently led to their entrapment.

This 'alien' quality that Tunbjörk described is a skill that stopped him from seeing too literally. For him, objects and actions just existed or occurred and did not need to be assigned meaning. This less literal approach to vision allowed Tunbjörk to see in more abstract terms. It created a disconnection between the eyes and the mind, which exposed all kinds of eccentricity in the everyday.

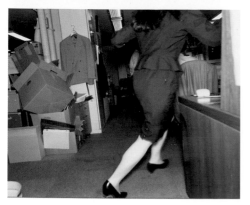
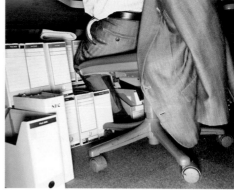
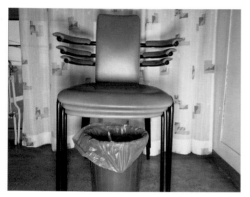
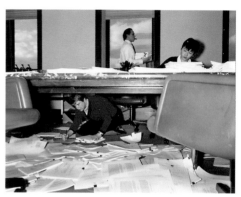

Untitled, from the series
'Office', 2002

'My photographs don't go below the surface. They don't go below anything. They're readings of what's on the surface.'

Richard Avedon

B: 1923 / **N:** American / **G:** Portraiture, fashion

The sitting was over, Richard Avedon was packing up and Marilyn was resting quietly in the corner. It was then that Avedon caught a rare glimpse of this consummate performer with her guard down. Even though Marilyn saw Avedon edging towards her, she held her pose and gave him what he was looking for – an intimate portrait that captures the inner vulnerability of a girl trapped behind a very public persona. But, as Avedon himself acknowledged, trying to capture, or reveal, anything other than what's on the surface is a fool's errand.

With his masterful ability to utilize the nuances of what's on the surface – facial expression, body language, hair, clothes and light – Avedon offered suggestions about his sitter's frame of mind. As for his audience, Avedon was well aware that we have a tendency to interpret these suggestions as facts, which in turn seduces us into seeing something that isn't there in the photograph, something that can never be there: the subject's aura, their psyche or even a glimpse into their soul.

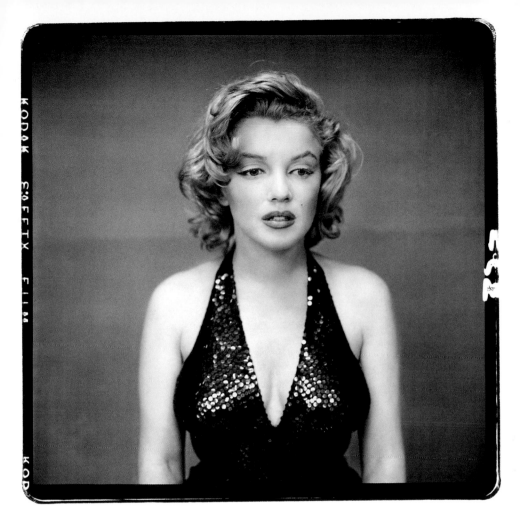

Marilyn Monroe, actress,
New York, May 6, 1957

'As a brown person, as a brown artist, your work is political. Whether you like it or not.'

Wendy Red Star

B: 1981 / **N:** American / **G:** Fine art

Wendy Red Star makes work about her Native American ancestors, the Crow, and how they have been represented in the past by 19th-century colonial photographers and more recently on TV and in Hollywood films. Here Red Star constructs a scene that places her in nature, yet the humorously artificial set-up references the ridiculous notion so often played out in mainstream media that Native Americans belong to the wild more so than to humanity.

Rather than being overtly political, Red Star sees her work as simply reflecting on who she is and the facets of her own cultural identity. It's no different to any other photographer making work informed by who they are. The issue is, however, that photography's long-established history would have us believe that it's an art form predominantly practised and appreciated by white people. They have become the default image makers so anyone outside of that status quo, no matter what their work may be about, is, to a certain extent, regarded as unusual or 'political'. And this is not solely an issue for non-white artists. You could easily substitute the word 'brown' in Red Star's statement for 'lesbian', 'Muslim', 'disabled' or even 'female'. Yet one thing you could not substitute it for is 'white', 'straight' or 'male'.

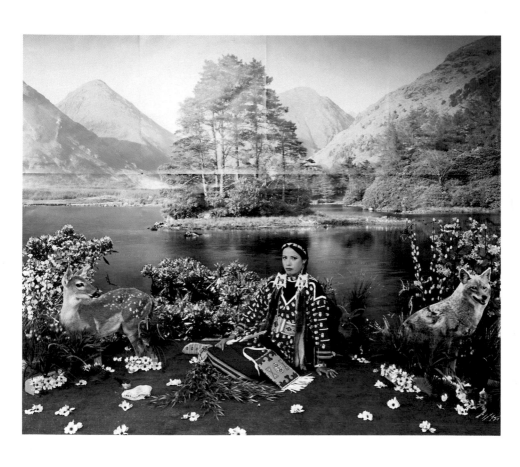

Spring, from the series
'Four Seasons', 2006

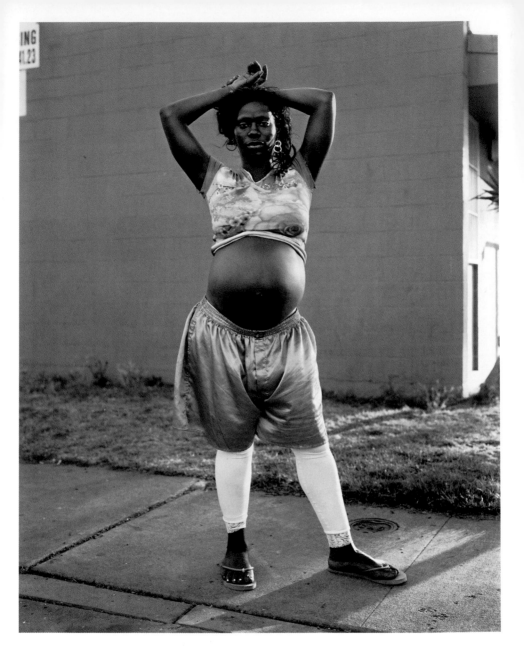

J 50, 2008, from the series
'Imperial Courts', 2008

'Being photogenic has nothing to do with looks.'

Dana Lixenberg

B: 1964 / **N:** Dutch / **G:** Portraiture

In photography, 'photogenic' refers to the physical appearance of a subject. In biology, 'photogenic' refers to an organism that emits light. I'm sure Dana Lixenberg would prefer the biological definition because it sums up exactly what she's saying here: that truly photogenic subjects are not the ones who display surface-level beauty like those featured on the cover of glossy magazines. They are the ones who emit another kind of energy. Something less physical, less mainstream. Something that goes way beyond the superficiality of a subject's 'looks'.

Here, there's so much energy, or charisma, flowing from the subject of this photograph, J 50, a resident of an LA housing estate called Imperial Courts. While J 50 is striking, Lixenberg is feeding off much more than what she looks like. Rather, the photographer is constructing the portrait around the subtlety of tones, textures and body language. These are the complex and ephemeral qualities that keep us looking. These are the qualities that make J 50 radiate something that's more akin to the elusiveness of light.

'It cannot be too strongly emphasized that reflected light is the photographer's subject matter.'

Edward Weston

B: 1886 / **N:** American / **G:** Landscape, nudes, still life

You could say that Edward Weston's range of subject matter was about as broad as a photographer can get. He trained his lens on deserts, flowers, water, shells, vegetables, people, architecture, nudes and even toilets. Yet you could also say that Weston only ever photographed one thing. In fact, you could say that all photographers only ever photograph one thing: reflected light.

We are taught that an object's physical shape and colour dictate what it looks like. Photographers like Weston show us that this is not the case; reflected light is what gives an object its form, texture and colour. In this image of a simple attic room corner, the light abstracts the surfaces to such an extent that our eyes can change the physical geometry of the architecture around the figure. Because Weston didn't see physical subjects as fixed or constant, he was able to reveal the abstract beauty that exists all around. For him, everything succumbed to the morphing powers of light.

Attic, Glendale, California, 1921

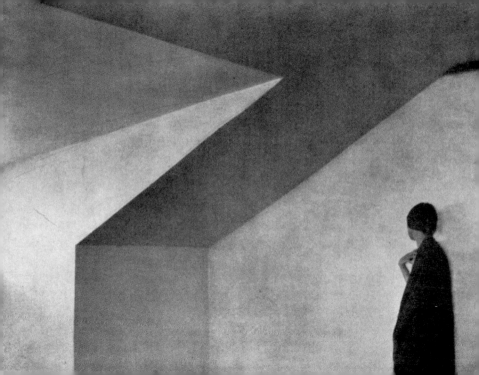

'Usually, the subject matter of the image is not the subject of the work.'

Roni Horn

B: 1955 / **N:** American / **G:** Fine art

Fine-art photographers are often drawn to a subject not for what it is, but for what it can represent. Roni Horn's work, which includes photography, sculpture and drawing, focuses on elements from nature as a means to reflect on history, cultural identity and a sense of place. Her series 'Some Thames' features photographs of the River Thames. Each composition is a close-up of the water's surface, which varies in appearance from placid to choppy, from cool blue to shimmering gold. It's the same river, it's the same water, but no two images are alike. Here the *subject matter* of the photographs is the river, but the *subject* is London, an ever-flowing city of poverty and wealth, tradition and diversity, culture and crime.

Of course, we can see these as just pictures of water. But where's the fun in that, because to limit our imaginations in such a way is to close ourselves off to the possibilities of photography, a medium that transforms reality into a two-dimensional world rich in metaphor and meaning.

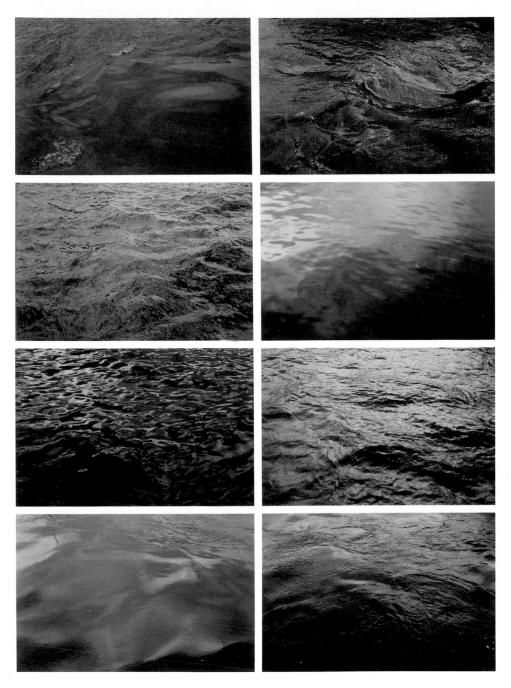

Group I and *Group J*, from the
series 'Some Thames', 2000

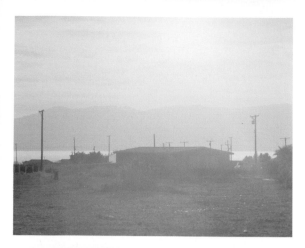

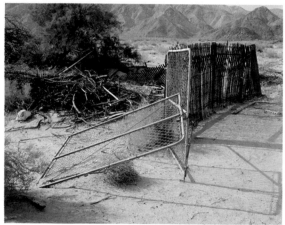

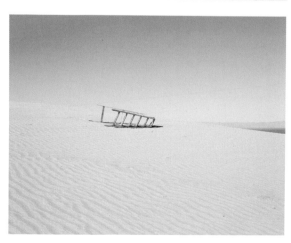

TOP:
House at Sunset,
from the series 'Lago',
2014

MIDDLE:
Leaning Fence,
from the series 'Lago',
2012

BOTTOM:
Ladder on Dune,
from the series 'Lago',
2011

'Metaphor should only bubble to the surface organically, and even then it's a good idea to keep a big stick around to beat it down.'

Ron Jude

B: 1965 / **N:** American / **G:** Fine art

For Ron Jude, metaphor is something that can flirt dangerously close to cliché. The problem for photographers, however, is that the line between originality and obviousness is extremely fine. What might seem like a clever and insightful visual association when shooting can feel a touch trite in the flow of a final edit.

With that in mind, constructing a series like 'Lago' that involved revisiting his youth and photographing the well-trodden deserts of the American West would have been like tiptoeing through metaphorical quicksand. Yet Jude manages to avoid any hint of clunky symbolism. His compositions tend to concentrate on singular subjects in the landscape, making them feel dislocated: broken fences, discarded tyres and blocks of concrete. As such, none are burdened with needing to be 'deciphered' or assigned specific meaning. Within the ebb and flow of the series, no single image carries the weight of being overly significant. Instead, from one to the next, the photographs operate as open-ended observations where metaphor gives way to mood.

RON JUDE

'What I offer as an artist doesn't lie in solely craft or visual acrobatics; it's in the context I create for individual images.'

Fence Repair #2,
from the series 'Lago',
2014

What makes you stop and photograph something? Is the act brought on by a conscious reasoning or more of an instinctive feeling about a tyre, a brick, a fence?

I usually give myself a destination when I go out shooting. I pick a place on the map and I start driving. Most of the time the end point on the map serves as an arbitrary location, however, just to get me out the door to start looking at the world. There may be some logic to why I choose a place, but I know that what I see along the way will probably be the most interesting part of the trip. It's often the case that I don't even make it to where I was headed. This Ouija Board method of working is the only way I know how to keep the image-making process one of discovery and surprise, without limiting the things I look at to a predetermined agenda. Anytime I've tried to work from a purely rational place, the photographs end up looking like lifeless illustrations. So in that sense, I'm guided by an instinctive feeling when I'm making photographs, but this feeling is always informed, to some degree, by the larger programme.

As you get further into shooting a series, and have a better idea of how it's forming, do you find that 'instinctive feeling' gives way to 'conscious reasoning' more often?

Somewhat, yes, but I try to make an effort not to intellectualize what I'm doing too much while I'm gathering raw material. Conscious reasoning comes into play to a larger degree when I'm piecing a book or exhibition together. But even then, I try to allow plenty of room for irrational choices. Rational thought will serve you well in forming thoughts about the work after it's finished (writing artist statements and grant proposals, or giving lectures), but can be a hindrance to finding new and surprising ways into a subject when you're still in production mode.

On the one hand your pictures appear like 'evidence', yet on the other, they seem to hold no obligation to 'truth', no more or less so than a memory does. I'm curious to know your stance on interfering with the objects and scenes you encounter.

I have no problem at all with the idea of manipulating a scene to benefit the picture. I don't consider what I do to be beholden at all to documentary integrity. My photographs are clear and uninflected in order to capitalize on what we expect from that sort of photograph, but that's as far as my relationship to documentary photography goes. That being said, returning to the first two questions, anytime I've tried to arrange things in a scene, it usually doesn't work. I leave the realm of instinct and move into an illustrative mode when I start playing around with things. There were a couple of images in 'Lago' that required some intervention, but it's something I try to stay away from most of the time.

Can you tell us a bit about your process in terms of shooting and editing?

I typically start a project with very broad strokes, which makes editing nearly impossible at that stage. It can literally be a year or two before things start to crystallize and I can see the material for what it might be beyond a bunch of pictures that I like. (I'm going through this process right now with some new work.) 'Lago' is the first project that I ever started editing prior to the completion of shooting, but even then I didn't start editing until after three years of shooting. I started working on the book during the last three months of making pictures. That worked out okay, but it's funny what having a glimpse of the outcome will do to your shooting. I had to catch myself a number of times when I went out with a mental checklist of things to find and photograph. That approach never works for me, for the aforementioned reasons.

Your series 'Lago' features still landscapes that feel timeless, insomuch as change would occur over a long time. You then punctuate these with pictures of people and animals, which naturally carry a greater sense of a moment. Can you tell us a bit about this push-and-pull and how you generally go about constructing the narrative arc of a series?

I don't have a formula for figuring out the structure of a book. I have ideas about pacing and rhythm and surprise, and I try to use those things to help guide me in making basic decisions, but ultimately the pictures themselves – the raw material – help me determine what shape the arc will take. But yes, the push-and-pull that you describe is consciously built into the sequence. I try to set up some basic parameters for how the pictures should interact. That's the first step. Once I understand how that's going to play out through a sequence, I then try to figure out ways to break my own rules without making the whole thing collapse. This allows for discernible patterns to emerge, but not at the expense of becoming repetitive and predictable.

Does a single photograph, one that is not supported by other images or text, hold any value or potential to you at all?

Although my work relies heavily on context for its ultimate impact, I've never abandoned the idea that individual pictures matter. Providing context for the photographs happens to a large degree in the editing stage, but when I'm on location making pictures, I'm completely concerned with singular images. I've never regarded individual photographs as simple 'illustrations' for the bigger idea. I'd like to think there is a fundamental visual integrity at the foundation of every effective sequence of images. One of my goals in making books or mounting exhibitions is to include the simple enjoyment of pictures as an essential part of the experience. I believe that without having

good, solid pictures as an access point, a large portion of the audience won't take the time to dig into the more coded and nuanced aspects of what I'm trying to convey. (This is something I look for in other artists' books and shows as well.) I still love well-crafted, visually surprising images that work on their own terms, in addition to serving the greater whole.

This might sound weird, but your photographs of the desert town where you grew up somehow remind me of my childhood. But I grew up in leafy London. Did you want 'Lago' to have that effect and if so why?

Yes, that's what I hope for with all of my projects, regardless of how specific they are in terms of place or even autobiography. I remember hearing a long time ago that Lisette Model once told Diane Arbus that, instead of attempting to photograph universal things, she should be as specific as possible. Through specificity, a sort of generality will emerge. This made a lot of sense to me as a young photographer and I took it to heart. If you're trying to do something with universal appeal and you water down the details in this attempt, you're likely to end up with nothing more than a very flat body of work that, due to its lack of texture, simply doesn't ring true. I think it's entirely possible to find meaning for oneself through the story of another person's life.

Moreover, the ultimate point of 'Lago' isn't grounded in a documentary representation of the California desert. That's the setting, but the impact of the work lies in its attempt to locate the disconnect between memory and experience, and how we all, whether in leafy London or arid Salton City, desperately attempt to smooth over that disconnect with narrative embellishments and outright fiction. We all need comfort in the face of nothingness and we tend to look for it in the coherent and sentimentalized stories we concoct about our lives. The further away from the chaos of lived experience we get, the easier it is to go to work

and prepare dinner for the kids without melting down in existential crises.

The American West has been, and still is, the subject for so many photographers. It's become such a loaded and political place, not just in reality but also in how it has been photographed. To what extent do you embrace or separate yourself from this history and the work of others?

I embrace that entire lineage, and as a young photographer I studied most of this work in great detail, particularly Timothy O'Sullivan and Robert Adams. Mark Ruwedel's work has such depth and focus to it that, as a fellow photographer, it can be humbling to look at. (Mark and I have covered a lot of the same territory in the desert. I even have a print of his hanging in my house. The image was made in Salton City, which is where a number of photographs in 'Lago' were also made.) Richard Misrach, of course, defined what work being done around Salton Sea might look like, and I had to consciously avoid certain times of the day out there, for fear of making Misrach retreads!

But apart from my admiration of these photographers, and even some visual similarities, I think my work takes off in a different direction. The Western landscape is a conduit for ideas that often attach themselves to the specificity of place, but those ideas can also be found elsewhere, in other places and altogether different subjects. I'd like to think that my work could be seen as a part of this lineage, but in a way that builds on it and departs from it, as much as continuing it. I think that this is what each of the above-mentioned photographers has done as well. There are many overlaps, the Western landscape being the most obvious, but they have all found unique vocabularies and their own specific interests within that landscape.

What's your favourite quotation on photography and why?

'Anyone can take pictures. What's difficult is thinking about them, organizing them, and trying to use them in some way so that some meaning can be constructed out of them. That's really where the work of the artist begins.'

Lewis Baltz

This quote is fundamental to my thinking about the medium of photography and lies at the heart of my process. As I mentioned above, I do find virtue in the strength of singular images, but at the end of the day, what I have to offer as an artist doesn't lie in solely craft or visual acrobatics; it's in the context that I create for the individual images. This is always a hard thing to get across to students — that what they're there to learn is not esoteric darkroom tricks or the detailed depths of Photoshop, but how to think about images as part of a system of thought. This is not to say that understanding one's tools isn't important, but it's only the first step.

RON JUDE
Ron Jude was born in Los Angeles but raised in rural Idaho. Ron's photographs have been exhibited at institutions such as The Photographers' Gallery in London, the Museum of Contemporary Photography in Chicago and the J. Paul Getty Center in Los Angeles. Ron lives in Oregon and teaches photography at the University of Oregon.

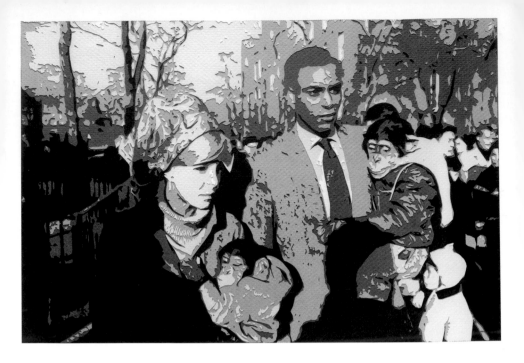

Couple Central Park Zoo, After
Garry Winogrand, from the series
'Pictures of Paper', 2008

'A photograph is never the same the second time you look at it.'

Vik Muniz

B: 1961 / **N:** Brazilian / **G:** Fine art

On turning the page you probably saw (or recalled) a Garry Winogrand photograph before almost instantly realizing something was up. Leaning in to inspect the picture further, maybe you then noticed that this 'Winogrand photograph' is, in fact, layers of cut-up card. And maybe you then realized something else, perhaps the most obvious thing of all: this is neither a Winogrand photograph nor layers of card. Like every other image in this book, it's just ink dots on a page.

With his series 'Pictures of Paper', Vik Muniz makes us aware that photographs are not as unchanging as we think. Depending on our physical distance, we can perceive a photograph as a singular entity or a universe of pixels or paper fibres. On repeated viewings, our eyes never take the exact same path around a photograph, meaning that we constantly receive the information in a different order. Time also plays its part. If you were to look at a photograph of your childhood self now and compare it to when it was taken, in what ways would your history make you regard it differently? For Muniz, photographs are fascinating, not because they can't tell stories, but because they have too many stories to tell.

Detail from *541,795 Suns from*
Sunsets from Flickr (Partial)
1/23/06, 2006

'Photography is a way of owning an object that you actually can't own.'

Penelope Umbrico

B: 1957 /**N:** American / **G:** Fine art

All of these photographs of the sun that Penelope Umbrico culled from Flickr are different. Some glow white, others yellow. Some burn against a blue sky, others amber. Some appear pointed, others form a perfect circle. One single sun becomes thousands and each incarnation belongs to the photographer who 'took' it.

For Umbrico, photography isn't just about preserving memories. It's also a way of claiming ownership of what we are seeing. When standing in front of the Grand Canyon, for example, putting a frame around the landscape and taking a photograph helps us to make sense of the sublime. It's an attempt to contain the uncontainable, to fathom the unfathomable. No longer does it exist 'out there'; it becomes the wallpaper on our phone, the banner to our social media pages or the canvas print that hangs above our sofa. Somewhere in this process of 'ownership' is also a subconscious act of defiance. These epic entities, which are far older and far more significant than us, threaten our sense of self. So to snap them is to conquer them.

'Photographs are only able to speak in the past tense.'

Ryūji Miyamoto

B: 1947 / **N:** Japanese / **G:** Documentary, fine art

At 5:46 am on 17 January 1995, the Japanese city of Kobe was shaken to its foundations by a violent earthquake. The quake lasted just 20 seconds and in that time 6,434 people died and much of Kobe was reduced to fire and rubble. Ryūji Miyamoto's photographs of the aftermath show contorted buildings collapsing in on themselves. Devoid of people, the structures appear like tombstones memorializing a devastating moment in history.

There is a doubling up of 'the past' in Miyamoto's photograph. Firstly, the subject matter makes us aware of an event that has taken place; here the subject is the past. Then, there is the photograph itself. All photographs are records of what has occurred. As soon as one takes a photograph, that moment slips from present to past. In reality, this building would have continued to crumble until it was knocked down, but here it is, unchanging and existing outside of time. In that respect, photographs are physical manifestations of the past. They are little objects (or bundles of data) that preserve moments from the fragility of our fading memory. Because they allow a direct channel into the past, you could say that time waits for no one, unless time is photographed.

Kobe Ekimae Building,
Chuo-Ku, from the series
'After the Earthquake', 1995

'I've always felt that our relationship to photography was conditioned by an underlying sense of loss.'

Bill Henson

B: 1955 / **N:** Australian / **G:** Fine art, portraiture

The sense of loss that Bill Henson feels is for the intangible world of silent stillness that exists within a photograph. Not only is a photograph a trace of the past; it also, in effect, represents another reality – one that the photographer creates but can never be a part of, like a window that can be looked through but never opened. This sensation is something we can feel when looking at Henson's photographs of teenagers floating above city lights and isolated in blackness. The subjects are suspended in an otherworldly photographic space. As people, they are themselves at a point of transition between youth and adulthood. A point where knowledge and self-awareness inevitably lead to its own loss, one that we have all experienced – the loss of innocence.

This longing for a reality that appears so real, but remains out of reach, stirs an emotional bond that no other visual art form can achieve. That's why, for Henson, photography is the undeniable medium of melancholy.

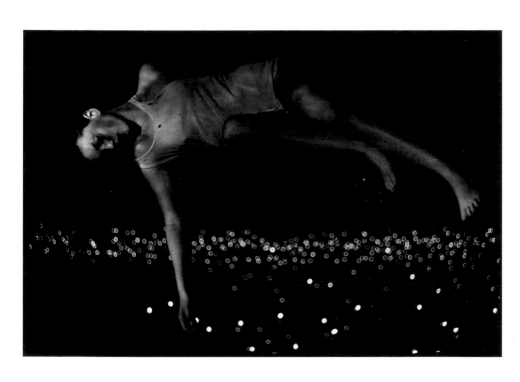

Untitled #20 *(LMO SH177 N2A)*,
2000−2003

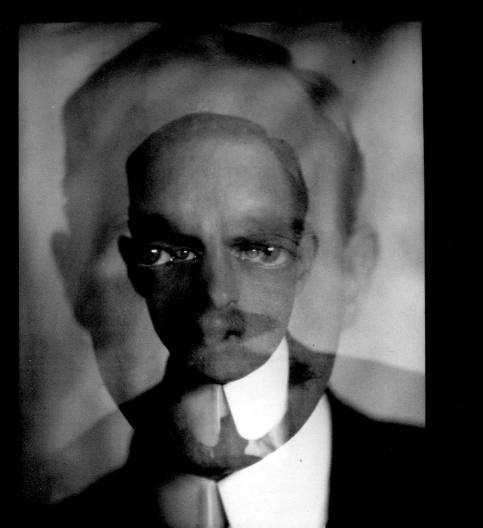

'In the days when men were burned at the stake for practising 'black magic', the photographer would have been an undoubted victim.'

Alvin Langdon Coburn

B: 1882 / **N:** American / **G:** Portraiture, fine art

Influenced by his growing fascination with mysticism and the occult, Alvin Langdon Coburn created photographs that were often alarming. Here the double exposure causes the subject to pulsate back and forth. Centred around staring eyes, the illusion of movement makes for a ghostly image that's intimidating and aggressive. Unlike an innocuous snapshot, the kind we endlessly create and consume today, this work suggests that there is something mysterious and perhaps threatening lurking within the medium of photography.

Coburn made his statement just over a hundred years ago, following the introduction of the small and easy-to-use Kodak Brownie camera. He saw that when photography became a medium for the masses, its uncanny powers of representation and creative potential started to be taken for granted. What was once an art practised by skilled professionals had become a frivolous pastime practised by the people. Like a voice from the grave, Coburn's statement serves as a reminder that photography, with its ability to 'capture light' and 'freeze time', is a form of magic. And every time we press the button, we are all, in effect, magicians.

'If I don't kill you, I can't move on.'

Ishiuchi Miyako

B: 1947 / **N:** Japanese / **G:** Reportage, still life

Following the Second World War, the US built a naval base in the Japanese town of Yokosuka. With such a large foreign military presence, Western ideals and exploits soon overpowered a traditional way of life and Yokosuka descended into a state of debauchery and sexual violence. Around ten years after she fled, Ishiuchi Miyako returned with her camera and photographed the murky alleyways and vulnerable women to create a portrait of a place overshadowed by an ominous, often unseen presence.

Photography was a way for Ishiuchi to reconcile her feelings towards Yokosuka, a place that had inflicted so much trauma on her in the past. But it was also a means of retaliation, because there is a certain violence imbedded in the act of photography, too.

'Shoot' a picture, 'fire' the shutter, 'capture' the subject, 'load' the film. Peel back photography's innocuous mask and underneath you will find an art form pulsating with aggression. This violence goes beyond mere terminology. The concentrated act of looking that photography so demands is, in itself, aggressive. We all know what it's like to be on the receiving end of someone's prolonged gaze – we become their prey. Conversely, we all know what it feels like to spy on someone from afar – we become the hunter.

TOP:
#73, from the series
'Yokosuka Story',
1976–77

BOTTOM:
#98, from the series
'Yokosuka Story',
1976–77

'For me, taking photos is not like shooting something: it's like being shot. I am shot.'

Lieko Shiga

B: 1980 / **N:** Japanese / **G:** Fine art

Here, Lieko Shiga suggests that the violence inflicted by photography somehow extends to the photographer. Shiga's photographs are mysterious; places are undefined, people are isolated in blackness and, in the case of this image, surreal, unexpected details prompt a double take.

Metaphorically speaking, Shiga uses photography as a means of suicide and resurrection. Her feelings are rooted in mysticism, consciousness and metaphysics, which might seem like foreign concepts at first – yet if we give in to it, it is possible to feel what it's like to be 'shot'.

Take a photograph, right now, of anything. At the moment of pressing the shutter, imagine you are severing time. Imagine, in that instant, everything that has come before is now contained in the photograph. Look at the photograph, see all your history within it. Imagine that you are now reborn.

Did you feel it?

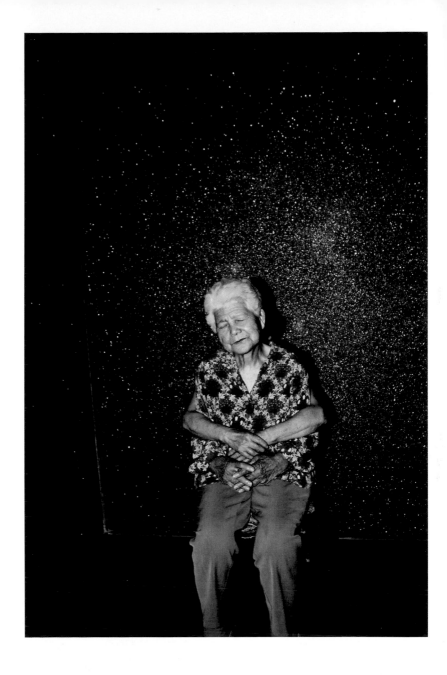

Mother's Gentle Hands,
from the series 'Rasen Kaigan
(Spiral Shore)', 2009

'There is a hidden promise built into the act of making a photograph.'

Broomberg & Chanarin

B: 1970 and 1971 / **N:** South African and British / **G:** Fine art

When Adam Broomberg and Oliver Chanarin photographed Mr Mkhize in South Africa, his picture had been taken only twice before – once for his pass book, so that the apartheid government could track his movements, and once for his identity book, so that he could vote in the country's first democratic election. Because Mr Mkhize has been photographed so little, and only for official reasons, this portrait carries a greater significance. By agreeing to be photographed he is offering up a precious gift: his self-image. And, for some reason, he has given it to two strangers, who, if they so wished, could use it against him.

Trust. That underlies the hidden promise that Broomberg and Chanarin refer to; trust that the photographer will use the gift of the subject's image for good. Yet as two artists preoccupied by the ecosystem of how photographs are made and disseminated, they know how easily this promise is broken. No matter what the original intentions of the photographer or subject, the lifespan of a photograph is long and changeable, and the reasons that led to it being taken can be stripped away. I wonder if Mr Mkhize asked Broomberg and Chanarin about their motives. I wonder what they told him. Because in offering up the gift of his self-image, he has inadvertently made himself entirely vulnerable.

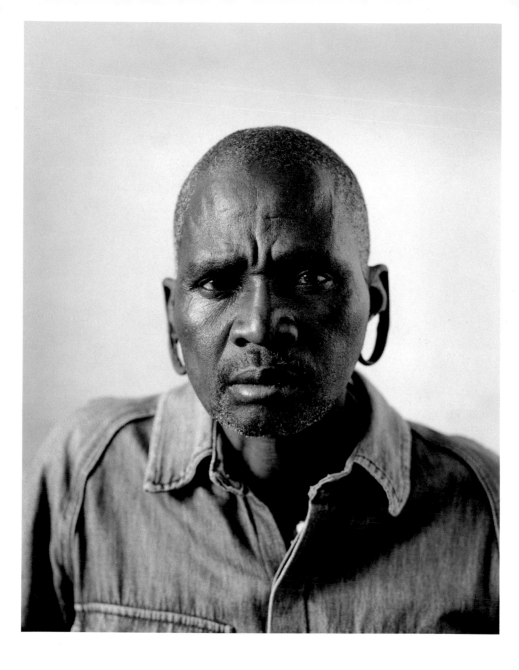

Mr Mkhize, Alexandria, S Africa,
2004

BROOMBERG & CHANARIN

'We've been overwhelmed by words and images for decades, if not centuries, now.'

An American and the Jap he killed. Pfc Wally Wakeman says: "I was walking down the trail when I saw two fellows talking. They grinned and I grinned. One pulled a gun, I pulled mine. I killed him. It was just like in the movies."

We saw each other – it happened very fast –
I smiled, and both of them smiled back at me.
And so at first we stood and smiled, all three.
One pulled his gun. And then I shot him dead.

When you photographed Mr Mkhize, were you, in a way, exploiting him? I don't mean that in an accusatory or negative way. I'm just wondering if this is an inevitable aspect of taking anyone's picture and perhaps something to do with why you both moved away from being behind the camera.

Yes, you are right, we were exploiting him. He had no idea we were going to use his image in a documentary, in exhibitions, in books, magazines or that it would one day be all over the internet. The moment we took his picture was only the third time Mr Mkhize had ever been photographed in his life. The first was for his pass book, which the apartheid government used to control the movement of anyone deemed 'non-white'. The second was for his ID document, which allowed him to vote in the first ever democratic election in South Africa in 1994. As far as Mr Mkhize was concerned, the third – this portrait we took of him – was also for official, bureaucratic reasons. There is a structural bias built into the photographic process, a one-way flow of power that favours the person behind the camera at the expense of the person in front of it. The history of photography is tied in with systems of cataloguing, of policing. So by simply standing behind the camera and making a portrait, you align yourselves with this system and with those in power.

When we scroll through the photo-fodder on Instagram and see incessant selfies, sunsets and salads, it's easy to dismiss it all as a load of meaningless visual junk. What's your stance on the whole 'too many pictures' debate and, in your opinion, is there such a thing as an entirely worthless photograph?

It's not very interesting to talk about the amount of images. We've been overwhelmed by words and images for decades, if not centuries, now. It's more interesting to look at how images are disseminated, how they are distributed. When we made the image of

Page from *War Primer 2*, 2011

Mr Mkhize,14 years ago, we felt relatively in control of how and who would use it. Now we would never be so presumptuous. Images are more and more difficult to harness or control than ever. In this new era, photographs are just another form of content, of data. Now the corporations controlling the distribution of data and the access to it are those in power. The image of Mr Mkhize is now just another form of data to be traded, content to be distributed. In this sense, every image is of some value – just not necessarily to the person in the image or the person who made the image.

The first interview in this book is with the 23-year-old fashion photographer Olivia Bee. She makes the point that because we have become 'immune to images', when we do encounter one that resonates, it is somehow more profound or its impact is heightened. Could you apply that same thinking outside of fashion photography and to photojournalism, because news images now – particularly those coming out of combat zones – tend to be so controlled or vetted, so when something does slip through it is actually made more powerful, or 'dangerous', by the system that tried to supress it?

That sounds about right. A friend of ours in Berlin, who is first and foremost an artist but also a refugee of Syrian descent, spent the first few years of his arrival guiding boats full of Syrians fleeing the war via the internet. He was often sent images of the 'collateral damage', images of wounded or drowned bodies. He was the person who decided to post the images of Alan Kurdi, the drowned Syrian boy lying face down on the beach. It was pretty much that image that galvanized the world into action on the refugee 'crisis'. So images can be powerful still, I don't think we are immune to them.

As artists who have used iconic imagery in your work, such as *War Primer 2*, I'm curious to know what factors you think help an image to become iconic and whether those factors have changed or been added to in more recent times?

We have often said that history coagulates around a certain moment or a certain image. We crave the soundbite, whether a fact or an image that can function as shorthand or a stand-in for a much more complex situation. The problem with these 'iconic' images or a factual soundbite is that it necessarily ignores that complexity, the ambiguity or subtlety of any given situation. With social media and the internet, the conditions of the production of these iconic images has changed a little. It is no longer just a handful of image distribution agencies that control the dissemination of images, but a handful of tech corporations like Google and Facebook. We're still just the passive consumers, although now we're tricked into the sensation of having some agency, by pushing a like button or unfollowing someone on Twitter or Instagram. These corporations have very few codes of conduct in place; they function under the broad principles of libertarianism and neo-liberal capitalism. We seem to keep coming back to looking at how images are distributed here.

You have written candidly about your experience judging the World Press Photo Award and I was really struck by your statement, 'We are asked to judge whether, for example, a photograph of a child suffocating to death in a mudslide is sufficiently beautiful to win a prize.' Is 'beauty' something that professional photojournalism needs in order to operate successfully and is the situation slightly different for citizen journalism?

There are many types of photojournalists and citizen journalists. It would be unfair to

generalize, but we would assume if you're trying to make money out of an image, people will have to want to consume it and people tend to want to consume something they find pleasing. Not necessarily beautiful, but satisfying or pleasing on some level.

Thinking about that word 'consume', generally speaking, news images taken by the public tend to conform less to traditional notions of what is visually satisfying in terms of composition, image quality, light etc. Yet we consume those just as readily. They are, perhaps, even more 'tasty'. For you, what secret ingredient(s) do these kinds of images contain that overpowers what they lack aesthetically?

We are not sure they 'lack' anything 'aesthetically'. In fact, their specific aesthetic characteristics suggest their urgency and their veracity. Images generated by the public are usually low resolution, sometimes blurred, often badly composed, sometimes not close enough and at other times too close to the action. These are just a few of the specific aesthetics that suggest that these images are 'truer' than those composed by professionals.

This question could be asked of any artist, I suppose, but it seems a bit more relevant to you guys due to the nature of your work and the way you challenge and expose the ecosystem of images. Is the art world the most effective context for your work and do you ever feel like you want to entirely break free from it, so that your work can have even greater impact?

We work in many worlds. This interview is part of our labour – as are teaching, making books, exhibitions in public institutions as well as private galleries, so we are not bound by the art world alone. Even if we were, there are many, many art worlds that you can function in. There are very critical, politically engaged art worlds and art worlds dedicated to making

decorative objects for your wall or coffee table, so again it is hard to generalize. We tend to move quite rapidly between various spaces and mediums, making it hard to monetize what we do but at the same time giving us the freedom to say what we want and not to have to worry about people's tastes or political allegiances.

What's your favourite quotation on photography and why?

'Everything was beautiful and nothing hurt.'

Kurt Vonnegut

ADAM BROOMBERG & OLIVER CHANARIN
Adam Broomberg was born in Johannesburg and Oliver Chanarin in London. Together they have had numerous solo exhibitions around the world and their work is held in major public and private collections, including Tate, MoMA, Stedelijk and the V&A. In 2014 they won the ICP Infinity Award for *Holy Bible* and in 2013 the Deutsche Börse Photography Prize for *War Primer 2*. Both are professors of photography at the Hochschule für bildende Künste (HFBK) in Hamburg.

'Still photographs are the most powerful weapons in the world.'

Eddie Adams

B: 1933 / **N:** American / **G:** Photojournalism

Captured by Eddie Adams on a humid day in Saigon, this iconic photograph shows General Nguyễn Ngọc Loan executing Nguyễn Văn Lém, the leader of a Vietcong terrorist cell. Unaware of what was about to unfold in front of the camera, Adams fired his shutter as the general fired his bullet. Lém died instantly, yet the moment of his execution ricocheted around the world, confronting people with the brutality of war in their homes and around their breakfast tables. It was a photograph that refused to be ignored and one that stirred enough public opinion to help bring an end to the Vietnam War.

Yet what is it about this photograph that makes it so powerful? What quality does it hold that affected so many people? The words used by Adams offer us a clue. He doesn't just say 'photographs', he says 'still photographs'. We can't deny that the moment captured is shocking, but it's the stillness of the photograph itself that makes what we are seeing so incendiary. The photograph insists that we linger on a single, brutal moment. Without sound, without movement, it distils the war into something that slots easily into our consciousness, like a ready-made memory. And once in our minds, there it remains, relentlessly unchanging.

Saigon Execution,
1968

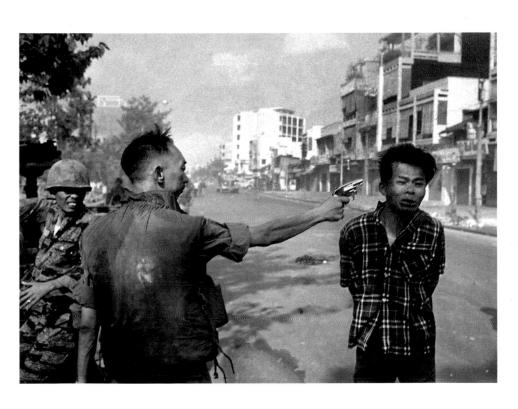

'Photography acts like the kiss of Judas: false affection sold for thirty coins.'

Joan Fontcuberta

B: 1955 / **N:** Spanish / **G:** Fine art

Like the disciple Judas Iscariot who eventually betrayed Jesus, photography may serve you as a friend, but its tenuous truths should always be questioned. Joan Fontcuberta has spent his career reminding us not to put too much faith in photographs. For instance, this picture titled *MN 27: VULPECULA (NGC 6853)* from his 'Constellations' series, shows what appears to be the night sky full of distant stars. However, the only signs of life here are, in fact, splattered flies on his car windscreen. Playful yes, but this makes Fontcuberta's work no less profound.

Digital manipulation and image sharing mean that we are now generally more aware that photographs bend the truth. Yet even so, we still find ourselves playing their game. From the simple act of using photographs to 'construct' our identities online to willingly believing the images that our preferred news outlets feed us, we knowingly take advantage of, and fall victim to, the half-truths told by photographs. For Fontcuberta, we have become trapped by the communication tool of our time, which begs the question: If we entirely reject photography's links to truth, what will it become and what meaningful role, if any, will it play in our lives?

MN 27: VULPECULA (NGC 6853) AR 19H 56,6'/ D +22° 43', from the series 'Constellations', 1993

'Isn't it remarkable how photography has advanced without improving?'

Charles Sheeler

B: 1883 / **N:** American / **G:** Fine art

Charles Sheeler made this remark to Ansel Adams on leaving an exhibition in New York. It's not known whose exhibition it was, but it seems clear that it didn't suit the tastes of the two veterans. Maybe for Sheeler, a photographer who strived for clarity and precision, the work was a bit too gimmicky in its use of modern techniques.

In terms of 'advancement', Sheeler must have been referring to technology and how this constantly leads to better cameras and processes, and how this makes photography ever-more accessible to all. Yet paradoxically, it would seem that all the technological advancements do not necessarily lead to 'improved' (or better) photographs and photographers. Sheeler's image from 1927 is a case in point. It's an exquisite depiction of space. Look at the precision of the framing, the distillation of the complex subject matter, those soft plumes contrasted with the ridged steel and the intriguing perspectival play of those intersecting walkways. Photographs – even those taken today with the most advanced cameras – don't get much better than this.

Of course, now more than ever, what is considered 'good' and 'bad', both in terms of cameras and photographs, is highly subjective. So perhaps it's best to move on from Sheeler's provocative statement by simply saying: *discuss ...*

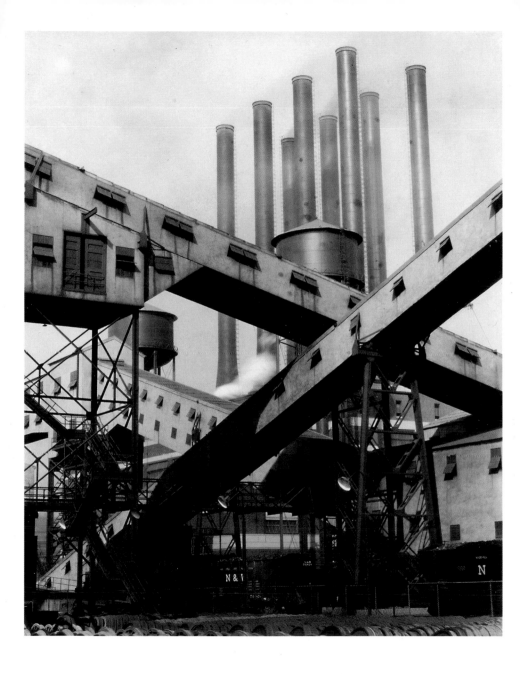

Criss-Crossed Conveyors,
River Rouge Plant, Ford
Motor Company, 1927

'Photography has relied on failed mimicry of human vision for too long.'

Brandon Lattu

B: 1970 / **N:** American / **G:** Fine art

While many photographers make work *using* photography, there are others, like Brandon Lattu, whose work is *about* photography. Photographer, painter, sculptor – call Lattu what you will, because that's just it. For him, the creative possibilities of 'traditional' photography have been exhausted and age-old classifications such as 'photography', 'painting' and 'sculpture' are no longer relevant. To move forward, photography must merge with other disciplines and break out of its established conventions of representation. Who's to say that a photograph needs to be flat, confined by four edges and the result of a single lens? These are boundaries that Lattu tests in his series 'Selected Compositions'.

Combining photography, digital ink printing, paper, polystyrene and wood, Lattu's three-dimensional works protrude from the gallery wall. Depending on how you physically approach them, you might first see a seductive block of solid colour, but as you move around, this colour fades into the different images that appear on each surface. Unlike a photograph that passively presents itself all at once, Lattu's works become something you explore and discover, something that redefines the relationship between vision and representation.

Selected Composition 5 [from the left], from the series 'Selected Compositions', 2012

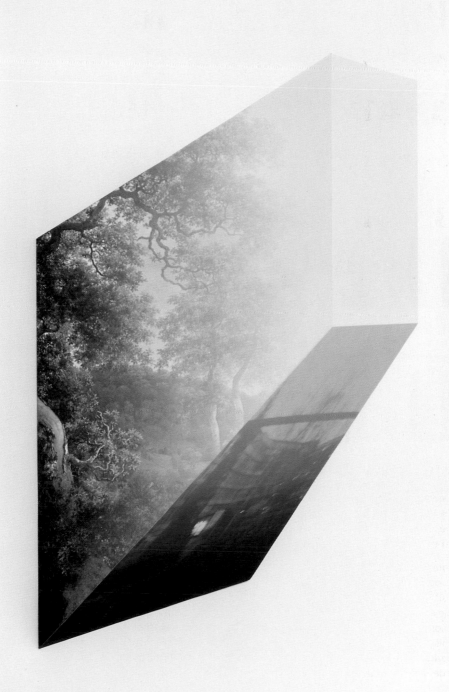

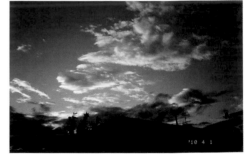

Untitled, from the series
'Chiro Love Death', 2010

'Photography was destined to be involved with death.'

Nobuyoshi Araki

B: 1940 / **N:** Japanese / **G:** Fashion, portraiture, reportage

In the years after his wife's passing, Nobuyoshi Araki photographed the ageing and eventual death of his beloved cat, Chiro. When we look at this sad series of Chiro growing weaker and weaker, we feel death all around. This feeling doesn't just arise from the subject matter; it comes from something else, something within photography itself.

If we were to describe, for example, a corpse, we might say that it is absolutely still and absolutely silent. We might also make the observation that it holds an uncanny resemblance to the living person – it is that person, but at the same time it isn't. Those same observations could be made about someone as they appear in a photograph. In other words, photography takes the life out of living subjects and renders them into 'corpses'.

Stillness, silence and a trace of what once was – these are inherent traits of photography, traits that for Araki will always carry an undercurrent of death. In that regard, poor old Chiro used his nine lives and then some, because he died every time Araki pressed the shutter.

'I do not profess to have perfected an art, but to have commenced one; the limits of which it is not possible at present exactly to ascertain.'

William Henry Fox Talbot

B: 1800 / **N:** British / **G:** Early photography

This is the world's earliest surviving negative. Made in 1835 by William Henry Fox Talbot, it depicts the fine detailing of a lattice window. Today, due to its fragile state, the negative is sealed inside a box because, if it were to be exposed to light, its image would fade to nothing in a matter of minutes. Who would have thought that light, the raw ingredient that gave birth to it, would eventually be responsible for its death? But then again, photography's story has, and always will be, hard to predict.

It's fitting, then, that even Fox Talbot, one of the key inventors of photography, wasn't quite sure what he had created, because we're still trying to ascertain its limits almost two centuries later. As a medium driven by technology and creativity, photography is constantly on the move and its social functions changing. Just when we think we know it, it repositions itself and morphs into something new.

Yet if we think about it, photography hasn't changed all that much, because its most magical quality, that thing separating it from all other art forms, remains the same: whether taken on film or with a phone, whether hanging in a gallery or saved on a computer, a photograph is captured light. For that reason, the ghost of photography's enigmatic origins will continue to haunt every film grain, every pixel and every line of code for a long time to come.

Latticed Window at Lacock Abbey, 1835

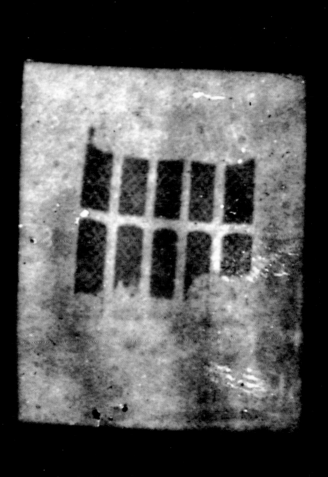

QUOTATION SOURCE CREDITS

8 Dorothea Lange: Nathan Lyons, ed., *Photographers on Photography: A Critical Anthology*, Prentice-Hall, 1966, page 69; **11** Irving Penn: 'Irving Penn: Centennial', exhibition at the Metropolitan Museum of Art of New York, **24** April–30 July, 2017; **12** attributed to Man Ray; **14** attributed to David Hockney; **16** Ansel Adams: quoted in Nathan Lyons, ed. *Photographers on Photography: A Critical Anthology*, Prentice-Hall, 1966, page 31; **19** Hellen van Meene: http://jmcolberg. com/weblog/extended/archives/a_conversation_with_hellen_van_meene/; **20** attributed to Daido Moriyama; **22** Fay Godwin: 'Fay Godwin: The Lie of the Land', *In With Mavis* (Channel 4), 1991, 5:01 minutes; **24** Olivia Bee: http://thephotographicjournal.com/interviews/olivia-bee/; **30** Ralph Gibson: *LFI Magazine*. Nov/Dec 2017.. http://www.guitarmoderne.com/artists/spotlight-ralph-gibson; **32** Saul Leiter: Sam Stourdzé, 'Saul Leiter or the art of going unnoticed' in *Saul Leiter – Colors*. Musée de l'Elysée, 2013; **35** Todd Hido: Todd Hido, *Todd Hido on Landscapes, Interiors and the Nude*, Aperture, 2014, page 59; **36** Maisie Cousins: http://www.dazeddigital.com/projects/article/29257/1/maisie-cousins; **39** Richard Misrach: http://aperture.org/blog/archival-interview-richard-misrach/; **40** Tacita Dean: 'Unconscious Journey: Tacita Dean in Conversation with Travis A. Diehl' in *Aperture* magazine, page 30; **43** Amalia Ulman: http://www.dazeddigital.com/artsandculture/article/23700/1/amalia-ulman-meme-come-true; **44** Alison Jackson: http://www.complex.com/style/2014/01/alison-jackson-interview; **46** Harley Weir: https://i-d.vice.com/en_au/article/8nykb/in-conversation-with-harley-weir; **49** Esther Teichmann: http://www.arterritory.com/en/texts/interviews/2819-when_i_take_pictures,_my_body_disappears._an_interview_with_esther_teichmann/; **54** Garry Winogrand: 'Garry Winogrand' exhibition at the San Francisco Museum of Modern Art, 9 March–2 June, 2013; **56** Jason Fulford: http://www.aaronschuman.com/jasonfulfordinterview.html; **59** James Welling: http://jameswelling.net/assets/uploaded/pdf/tillman_lynne_in_conversation.pdf; **60** attributed to Lisette Model; **62** Paul Graham: https://www.theguardian.com/artanddesign/2011/apr/11/paul-graham-interview-whitechapel-ohagan; **64** Viviane Sassen: http://time.com/3795824/waking-dream-viviane-sassens-fashion-photography/; **66** Laia Abril: https://www.lensculture.com/articles/laia-abril-tediousphilia; **68** Gillian Wearing: http://www.independent.co.uk/news/people/profiles/gillian-wearing-the-art-of-the-matter-91846.html; **71** Alec Soth: http://erickimphotography.com/blog/2011/09/26/35-magnum-photographers-give-their-advice-to-aspiring-photographers/; **77** John Baldessari: Carrie Rickey (ed.), Nancy Drew, *John Baldessari: An Interview*, The New Museum, co-published with University Art Galleries, Wright State University, Dayton, Ohio, 1981. http://corescholar.libraries.wright.edu/cgi/viewcontent.cgi?article=1003&context=restein_catalogs; **78** Lars Tunbjörk: http://www.americansuburbx.com/2012/02/lars-tunbjork-alien-at-the-office-2004.html; **80** Richard Avedon: https://www.portrait.gov.au//magazines/46/the-avedon-effect; **82** Wendy Red Star: http://aperture.org/blog/wendy-red-star/; **85** Dana Lixenberg: https://www.vice.com/en_au/article/mossless-in-america-dana-lixenberg; **86** attributed to Edward Weston; **88** attributed to Roni Horn; **91** Roni Jude: http://www.americansuburbx.com/2015/12/a-conversation-with-ron-jude-the-staccato-memory.html; **97** Vik Muniz: http://bombmagazine.org/article/2333/vik-muniz; **99** Penelope Umbrico: http://aphotoeditor.com/2016/04/27/penelope-umbrico-interview/; **100** Ryūji Miyamoto: Ivan Vartanian, Akihiro Hatanaka, Yutaka Kambayashi (eds.), *Setting Sun Writings by Japanese Photographers*, Aperture, 2006, page 78; **102** Bill Henson: Susan Bright, *Art Photography Now*, 2ⁿᵈ ed., Thames & Hudson, 2011, page 98; **105** Alvin Langdon Coburn: Nathan Lyons, ed., *Photographers on Photography: A Critical Anthology*, Prentice-Hall, 1966, page 54; **106** Ishiuchi Miyako: http://aperture.org/blog/interview-ishiuchi-miyako/; **108** Lieko Shiga: http://www.tokyoartbeat.com/tablog/entries.en/2008/10/ghosts-in-the-lens. html; **110** Broomberg & Chanarin: http://cphmag.com/convo-broomberg-chanarin/; **116** Eddie Adams: http://content.time.com/time/magazine/article/0,9171,139659,00.html; **118** Joan Fontcuberta: Joan Fontcuberta, *El beso de Judas, Fotografía y verdad*. Editorial Gustavo Gili, 1997; **120** Charles Sheeler: Ansel Adams and Mary Street Alinder, *Ansel Adams, An Autobiography*. Little, Brown and Company, 1996, page 173; **122** Charlotte Cotton, *Photography is Magic*. Aperture, 2015, page 361; **125** Nobuyoshi Araki: http://photobookclub.org/2011/11/07/nobuyoshi-araki-video-documentary-and-interview/; **126** William Henry Fox Talbot: 'The New Art', *The Literary Gazette and Journal of belles lettres, science and art*, no. 1150, 2 February 1839, page 73. http://foxtalbot.dmu.ac.uk/letters/transcriptDocnum.php?docnum=3782

PICTURE CREDITS

9 Library of Congress; **10** © The Irving Penn Foundation; **13** Metropolitan Museum of Art. Ford Motor Company Collection, Gift of Ford Motor Company and John C. Waddell, 1987. Accession Number: 1987.1100.42. Image copyright The Metropolitan Museum of Art/Art Resource/Scala, Florence. © Man Ray Trust/ADAGP, Paris and DACS, London 2018; **15** Photographic drawing printed on paper, mounted on Dibond. Edition of 25. 33 1/4 × 46". © David Hockney. Photo Credit: Richard Schmidt; **18** U.S. National Archives (Records of the National Park Service); **21** Courtesy Daidō Moriyama Photo Foundation; **23** © Fay Godwin/Collections Picture Library; **25-26** © Olivia Bee/Trunk Archive; **31** © Ralph Gibson; **33** © Saul Leiter/Courtesy Howard Greenberg Gallery, New York; **34** © Todd Hido; **37** © Maisie Cousins/Courtesy T.J. Boulting; **38** © Richard Misrach, courtesy Fraenkel Gallery, San Francisco; **41** Courtesy of the artist, Frith Street Gallery, London and Marian Goodman Gallery, New York / Paris. Photo credit: Alex Yudzon; **42** Courtesy the Artist and Arcadia Missa; **45** © Alison Jackson; **47** © Harley Weir/Art Partner; **48, 50** Courtesy of the artist; **55** © The Estate of Garry Winogrand, courtesy Fraenkel Gallery, San Francisco; **57** Courtesy and © Jason Fulford; **58** © James Welling, courtesy Maureen Paley, London and Regen Projects, Los Angeles; **61** Private collection/© The Lisette Model Foundation, Inc. (1983). Used by permission; **63** © the artist, courtesy Anthony Reynolds Gallery, London; **65** © Viviane Sassen; **67** © Laia Abril; **69** © Gillian Wearing, courtesy Maureen Paley, London, Regen Projects, Los Angeles and Tanya Bonakdar Gallery, New York; **70, 72** © Alec Soth/Magnum Photos; **76** Courtesy of John Baldessari; **79** Photograph by Lars Tunbjörk/ Agence Vu/Camera Press London; **81** Photograph by Richard Avedon © The Richard Avedon Foundation; **83** © Wendy Red Star; **84** © Dana Lixenberg; **87** © Center for Creative Photography, The University of Arizona Foundation/ DACS 2018; **89** © Roni Horn/Hauser & Wirth; **90, 92** © Ron Jude; **96** © Vik Muniz/VAGA, New York/DACS, London 2018; **98** © Penelope Umbrico; **101** © Ryūji Miyamoto/Courtesy of Taka Ishii Gallery, Tokyo; **103** Courtesy Bill Henson and Tolarno Galleries, Melbourne; **104** George Eastman Museum, gift of Alvin Langdon Coburn. 1979.4061.0009/© The Universal Order; **107** © Ishiuchi Miyako/courtesy of The Third Gallery Aya; **109** © Lieko Shiga; **111** © Broomberg & Chanarin. All Rights Reserved, DACS. 2018; **112** Courtesy of the artists and MACK; **117** Eddie Adams/AP/Shutterstock; **119** Courtesy and © Joan Fontcuberta; **121** Digital image, The Museum of Modern Art, New York/Scala, Florence. © Charles Sheeler/The Museum of Fine Arts Boston; **123** Courtesy the artist and Koenig & Clinton, Brooklyn. Private Collection, Brighton, Colorado. © Brandon Lattu; **124** © Nobuyoshi Araki/Courtesy of Taka Ishii Gallery, Tokyo; **127** Science and Society Photo Library.

FURTHER READING

This book touches on many ideas that are explored further in other thought provoking books on photography. To ease you in, I've loosely listed them here in order of accessibility:

Adams, Robert. *Why People Photograph* (New York: Aperture, 2004).

Shore, Stephen. *The Nature of Photographs* (2nd edition) (London: Phaidon, 2007).

Wells, Liz. *Photography: A Critical Introduction* (3rd edition) (Oxford: Routledge, 2004).

Larsen, Jonas and Sandbye, Mette, ed. *Digital Snaps: The New Face of Photography* (London: I.B.Tauris, 2013).

Fontcuberta, Joan. *Pandora's Camera* (London: Mack, 2014)

Sontag, Susan. *On Photography* (London: Penguin, 2008).

Benjamin, Walter. *The Work of Art in the Age of Mechanical Reproduction* (London: Penguin, 2008).

Flusser, Vilém. *Towards a Philosophy of Photography* (London: Reaktion, 2000).

Barthes, Roland. *Camera Lucida: Reflections on Photography* (New York: Hill and Wang, 2010).